T0040230

# Parks and Recreation

## THE OFFICIAL COLORING BOOK

ILLUSTRATIONS BY **VALENTIN RAMON**

INSIGHT
EDITIONS

San Rafael • Los Angeles • London

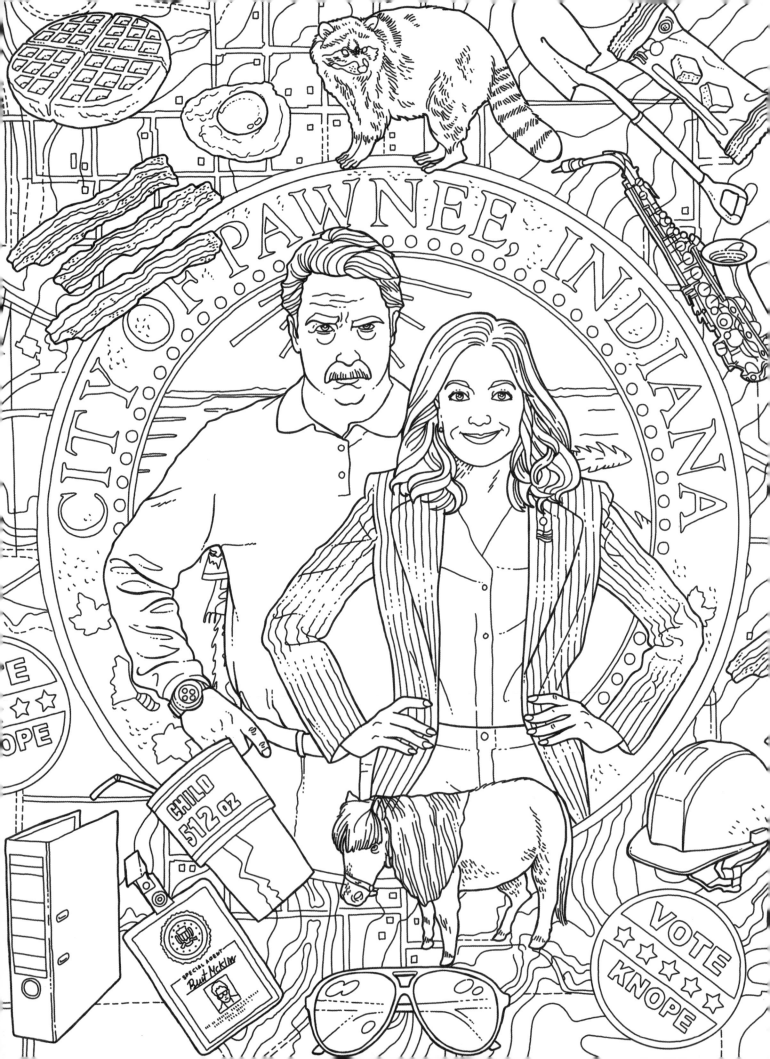

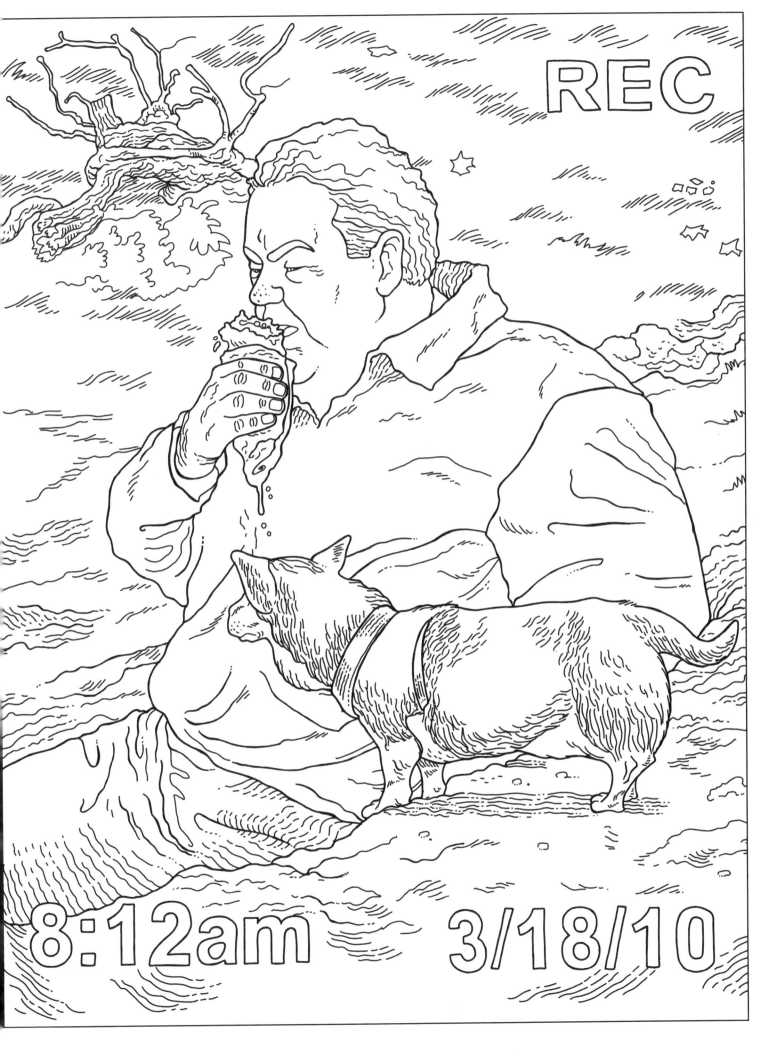

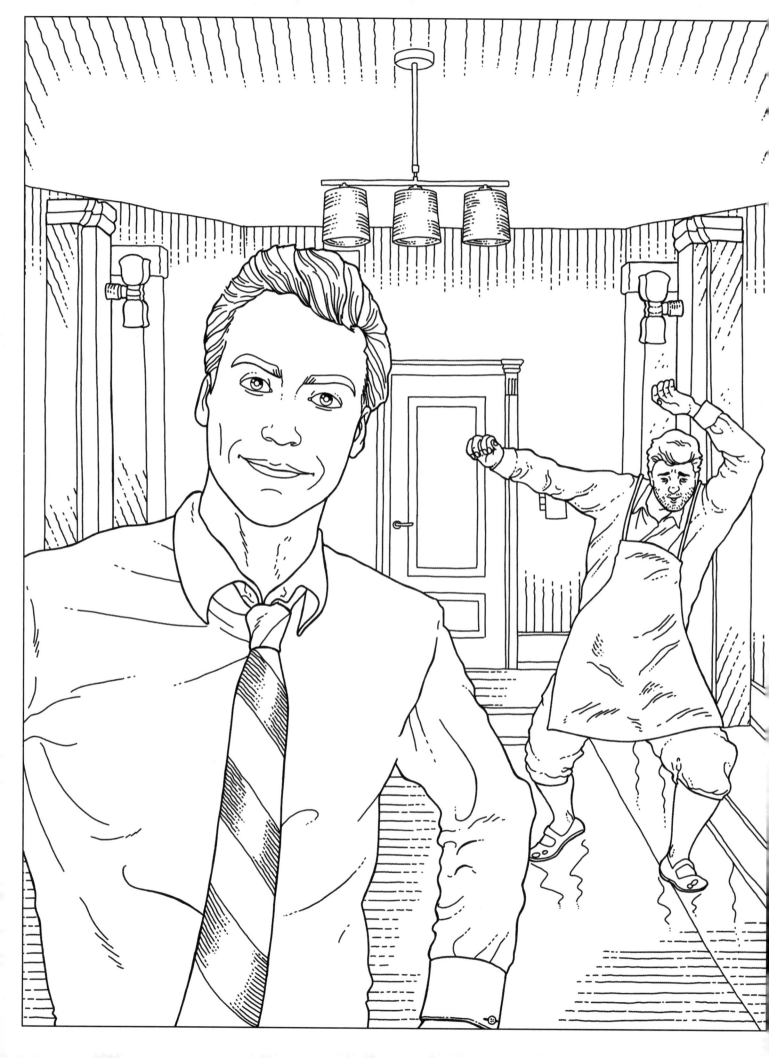

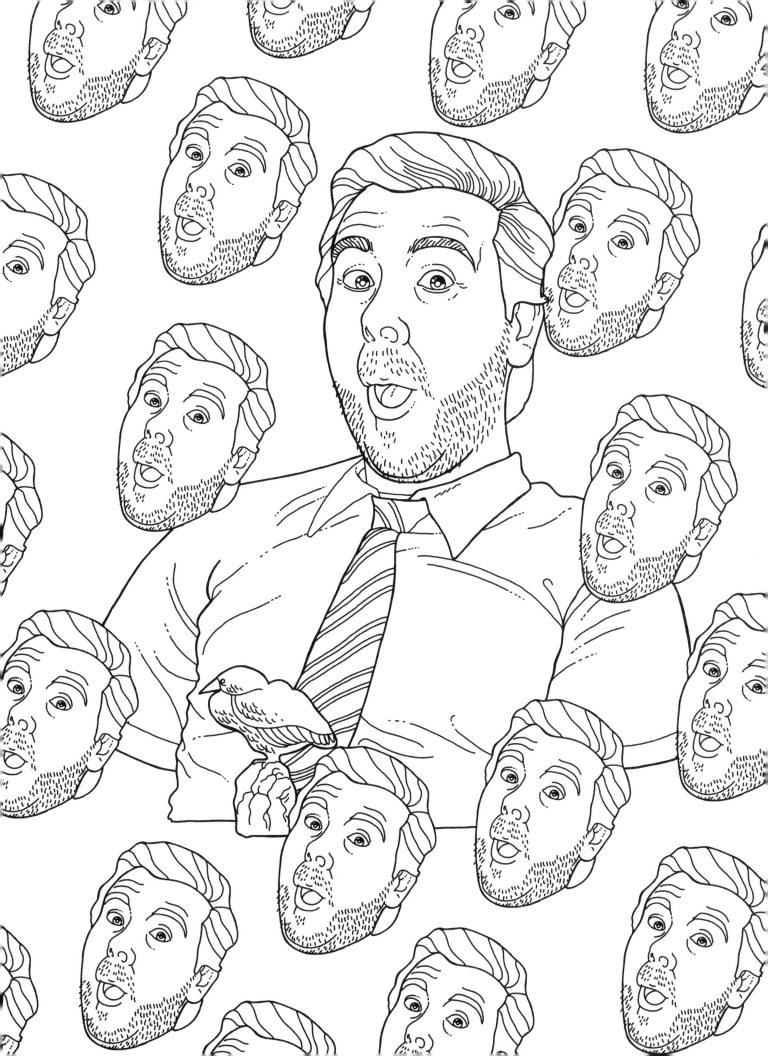

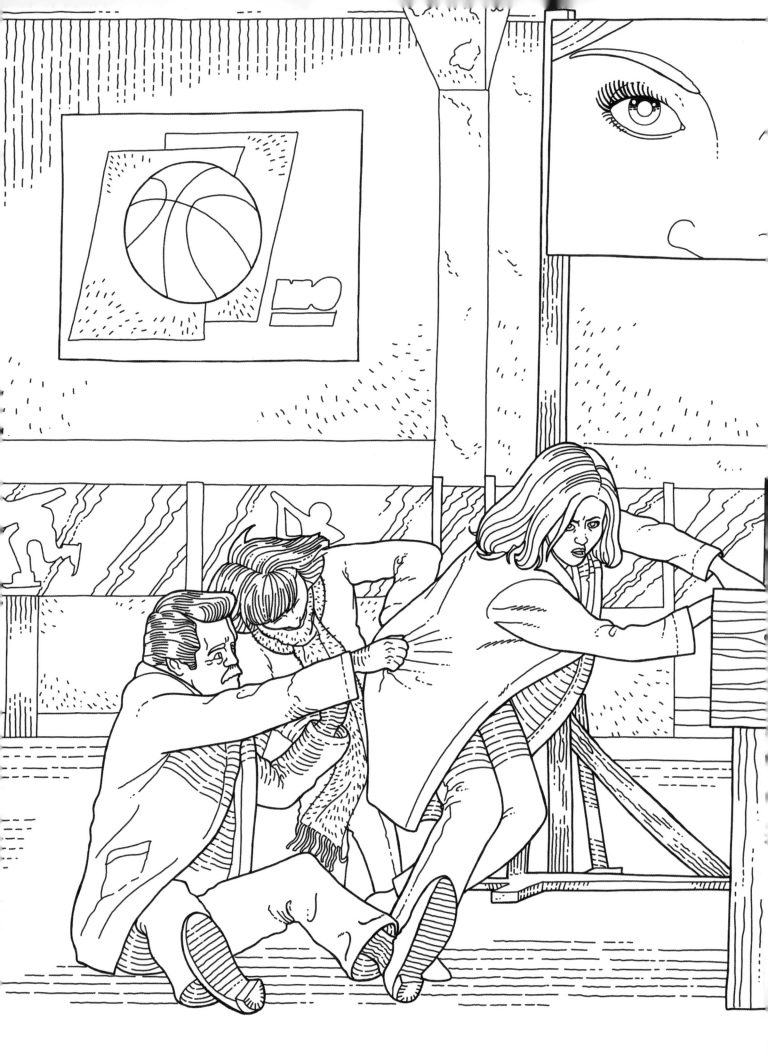

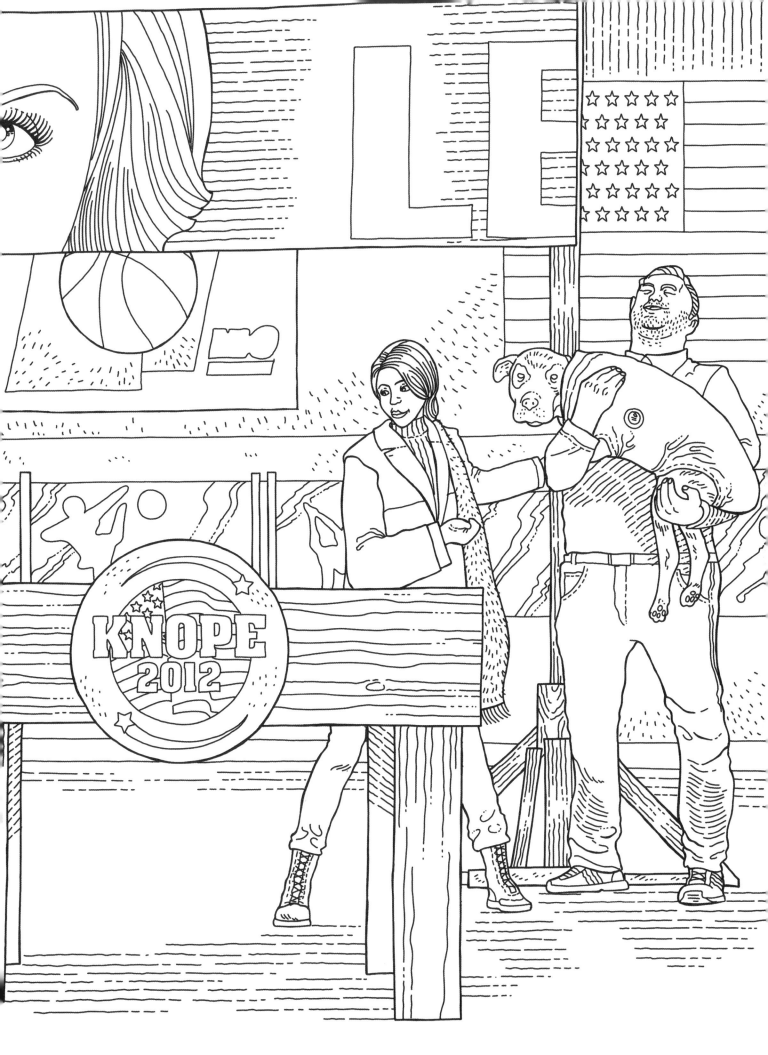

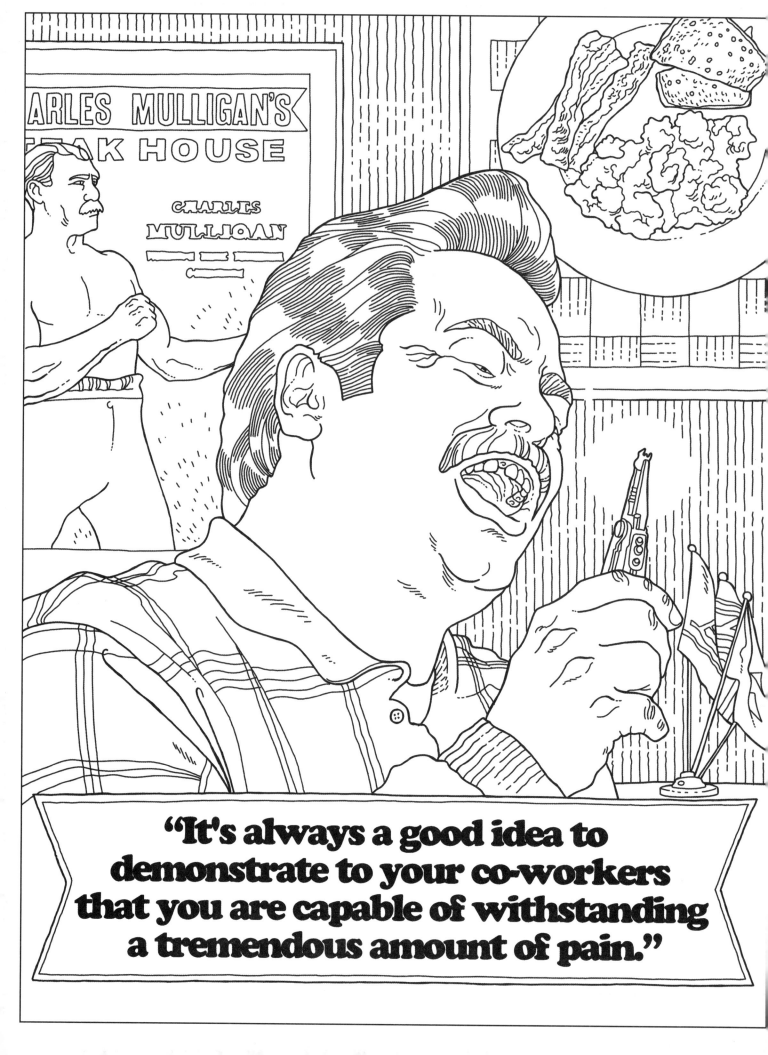

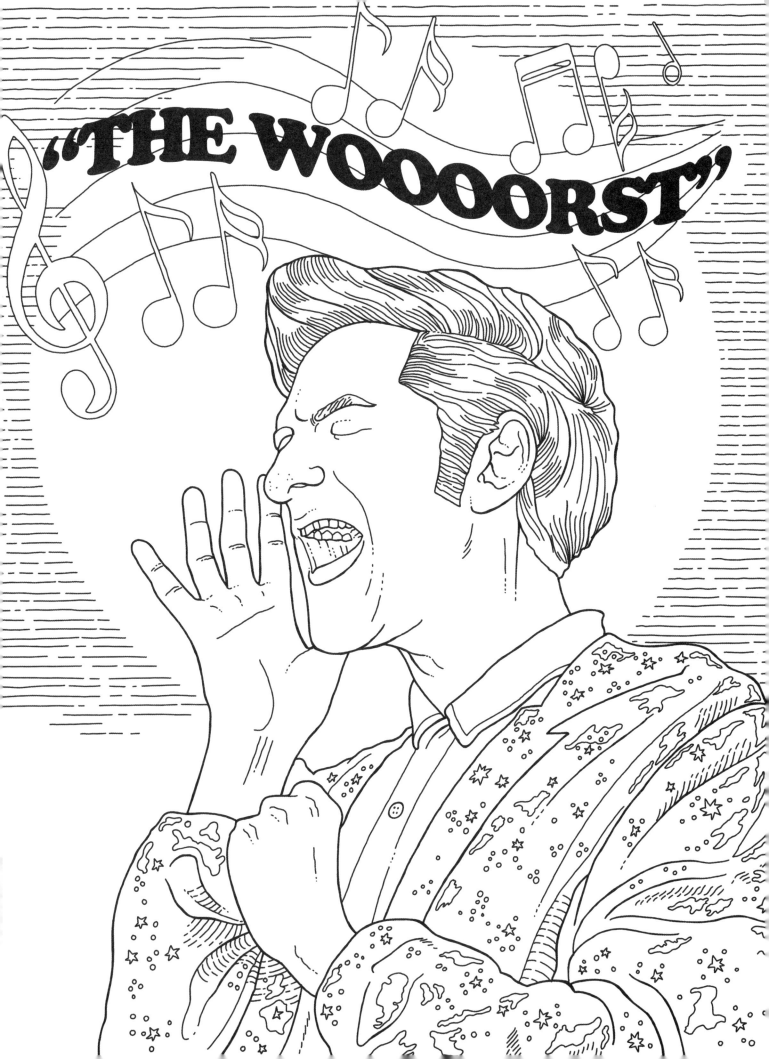

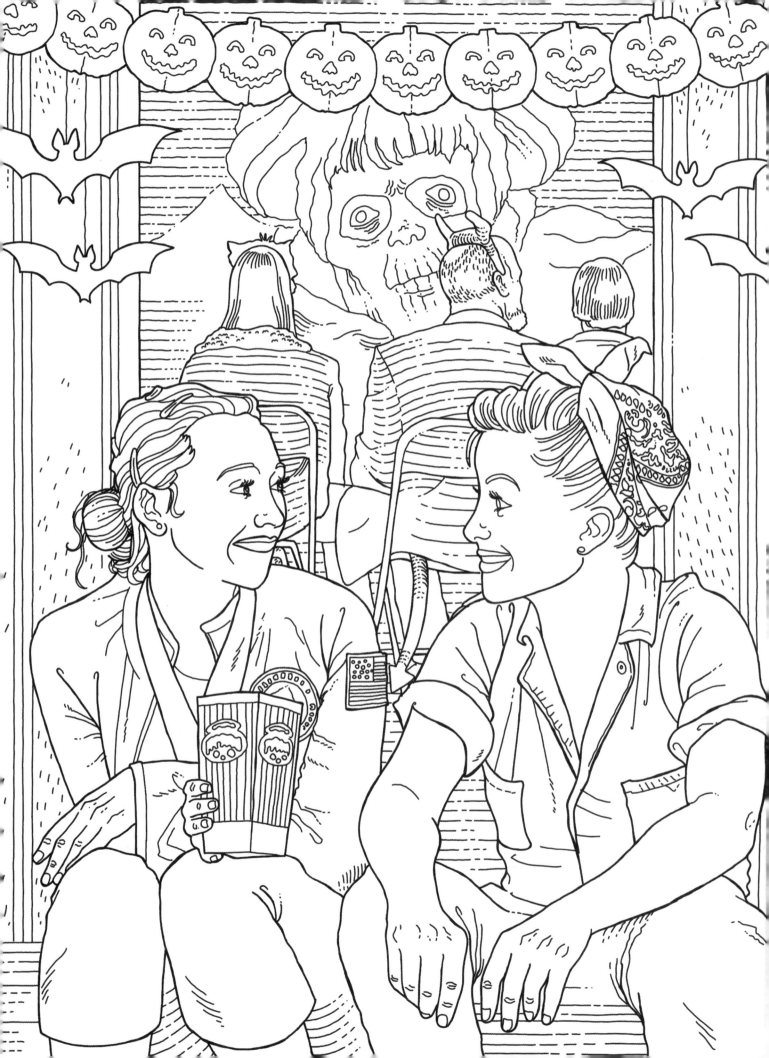

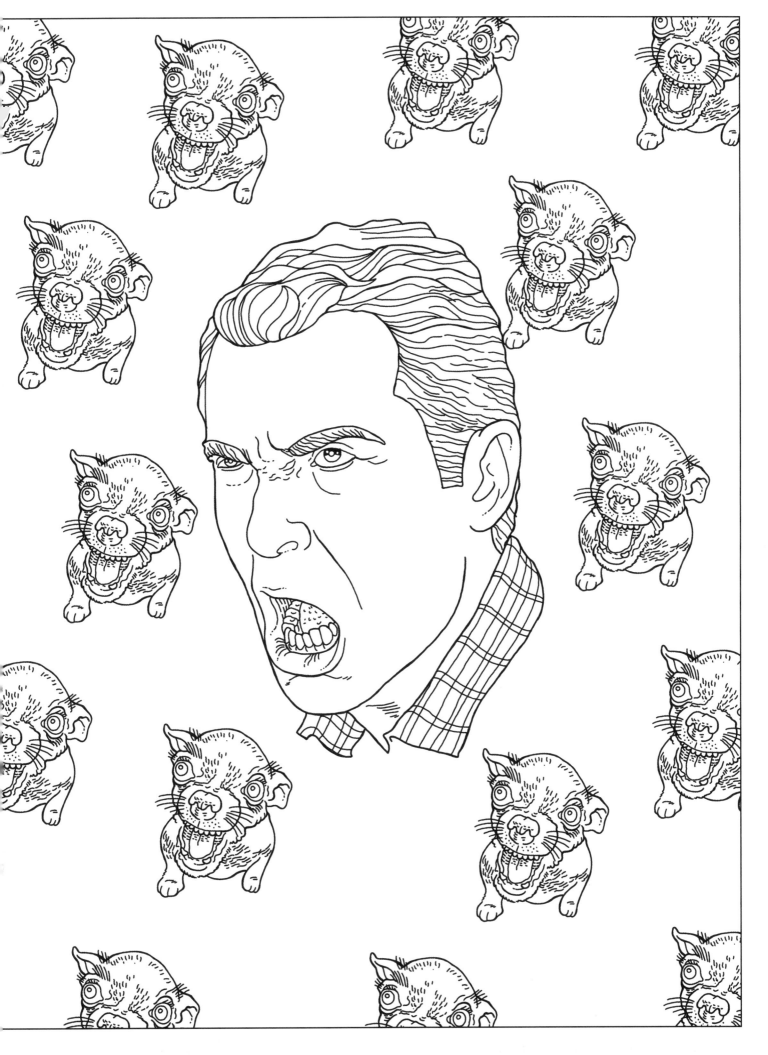

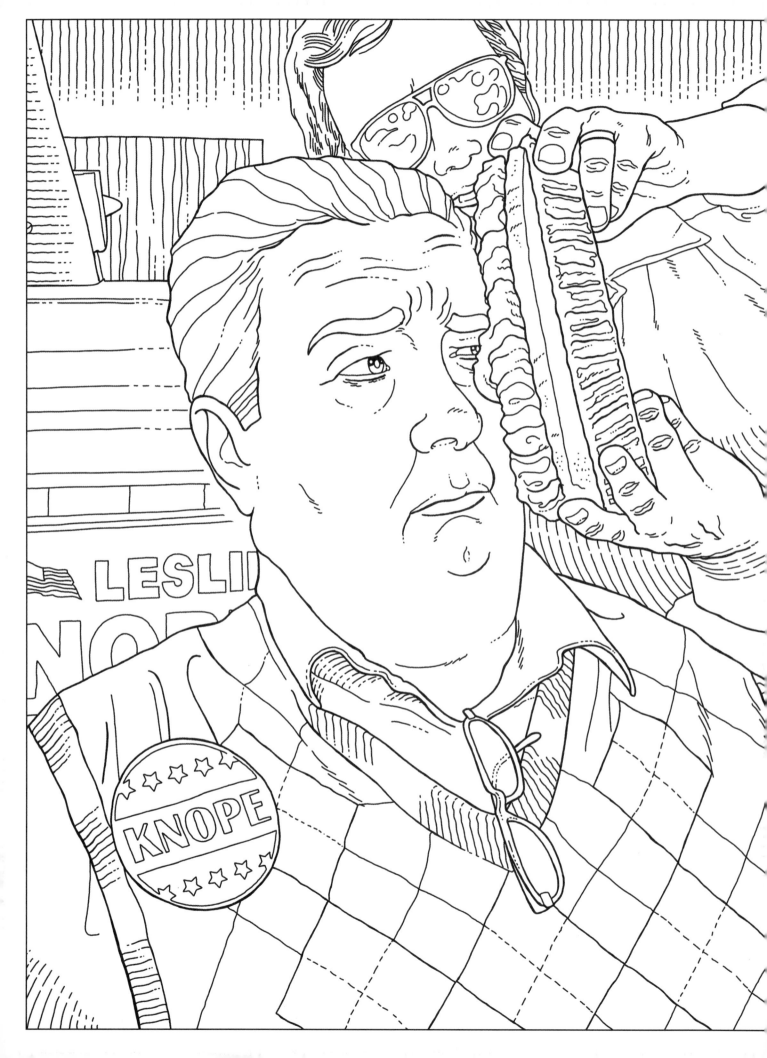

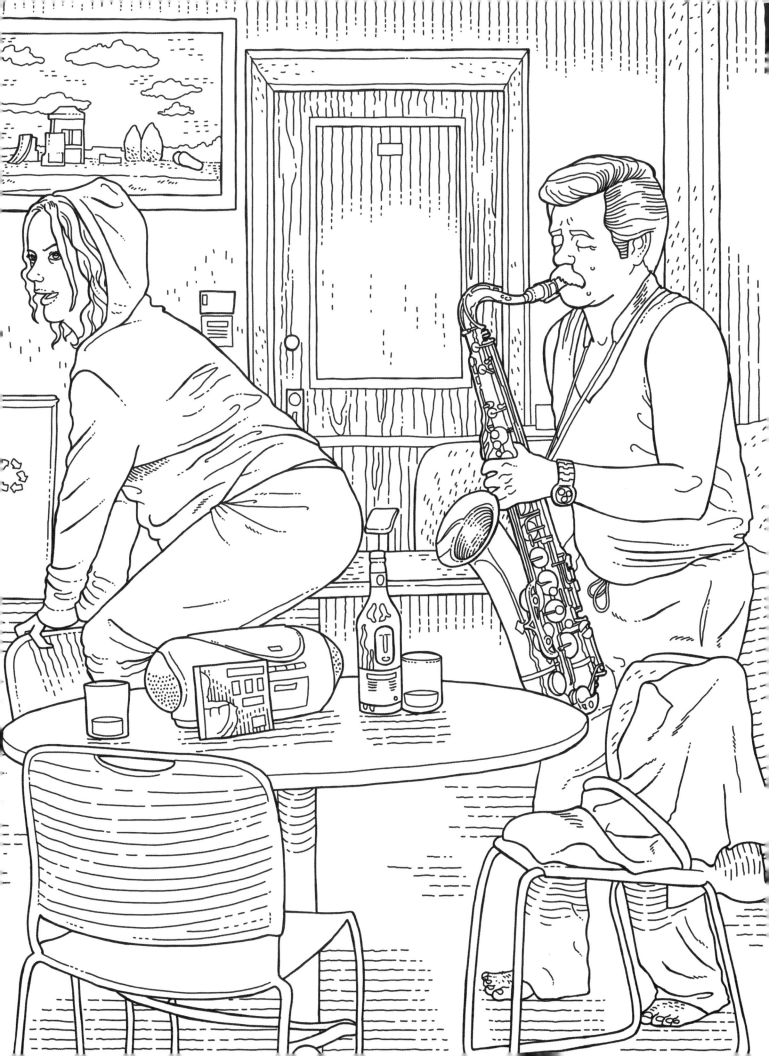

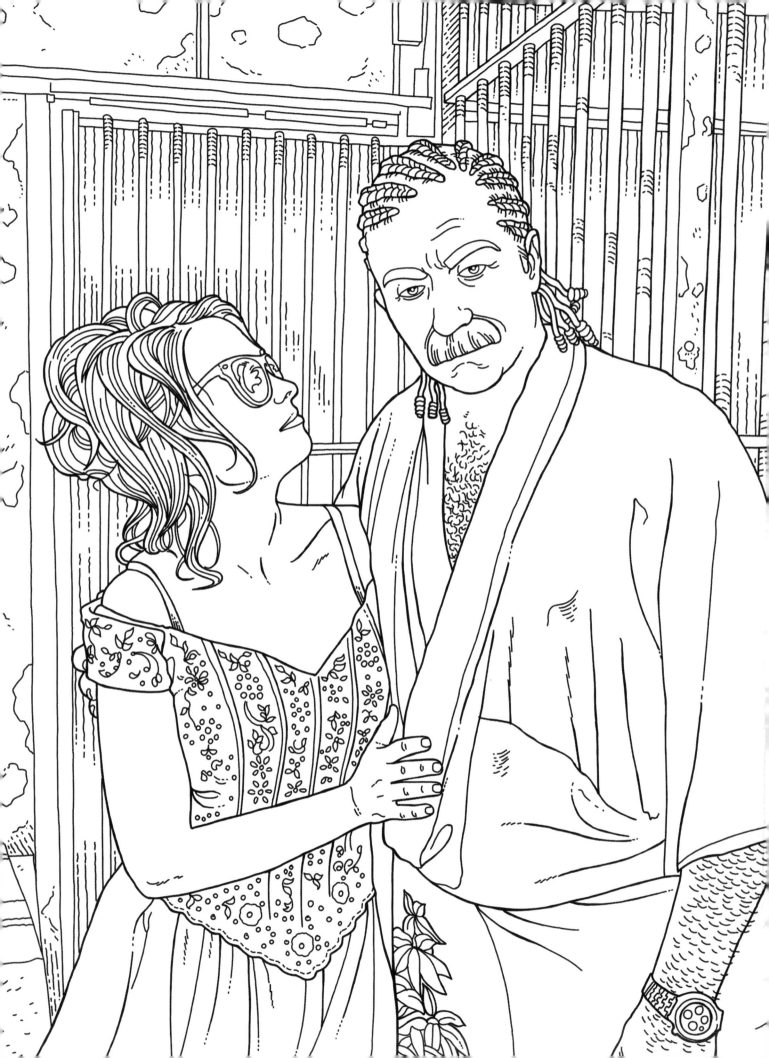

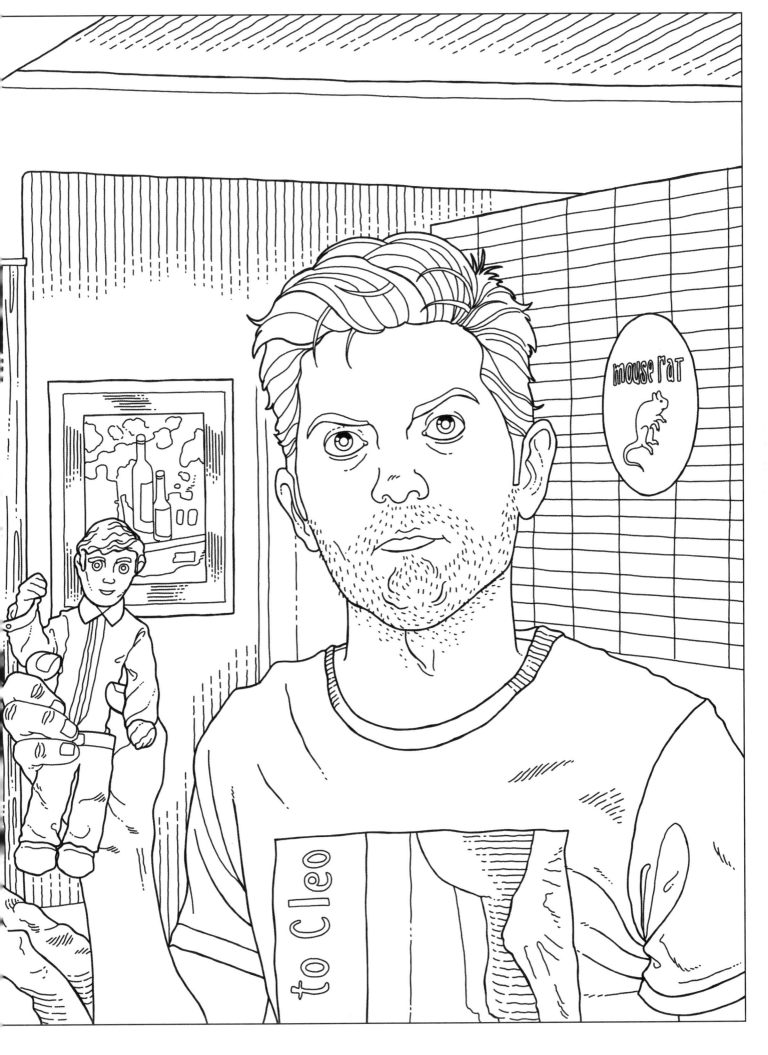

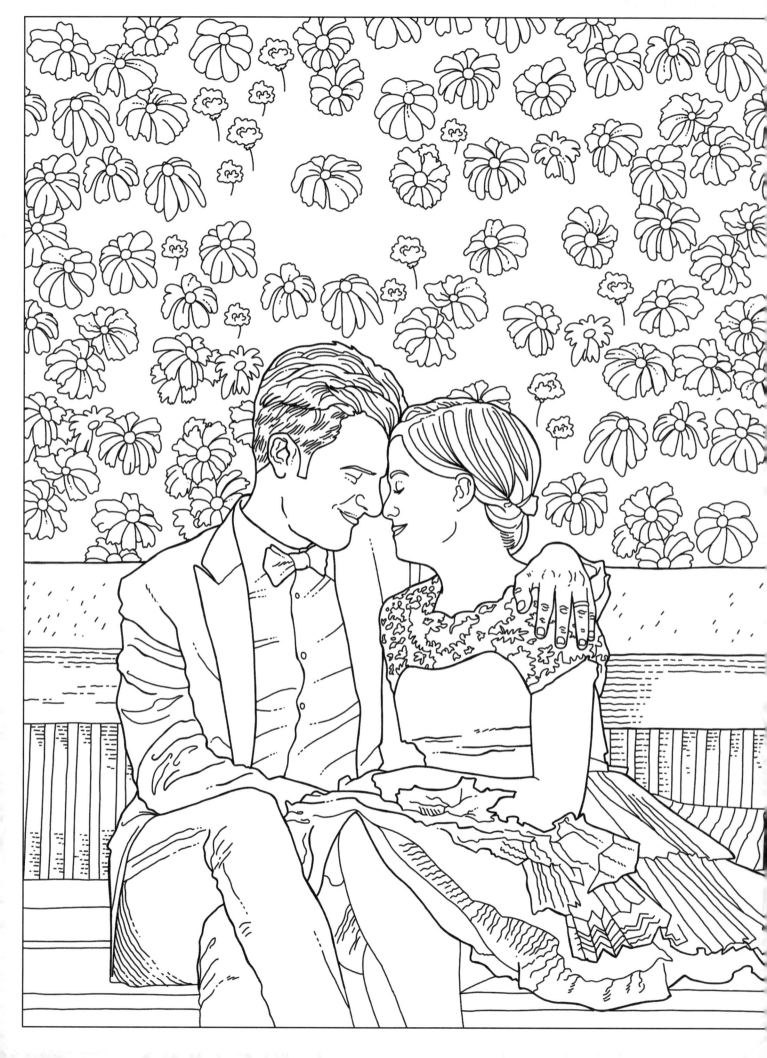

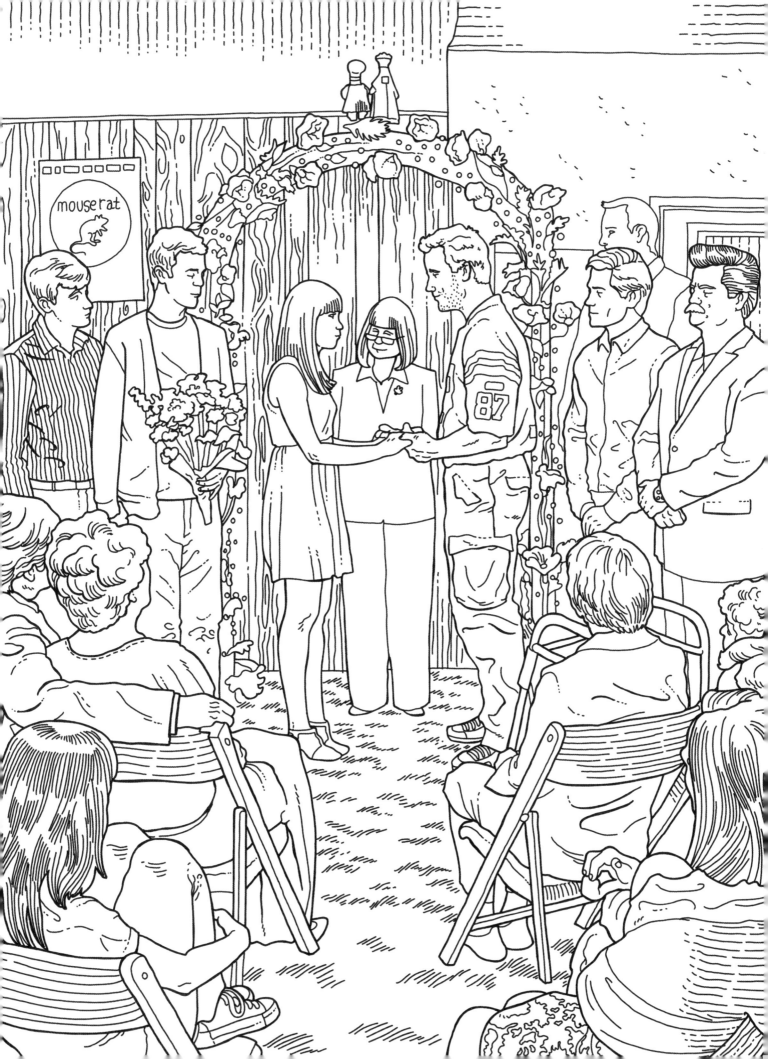

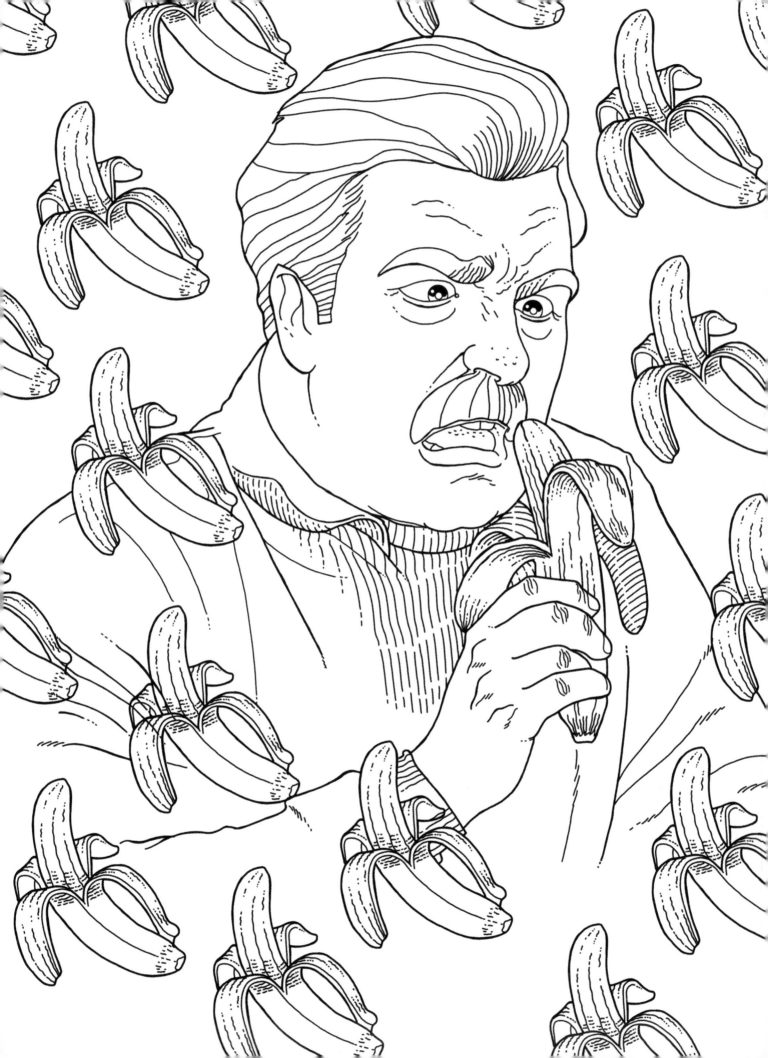

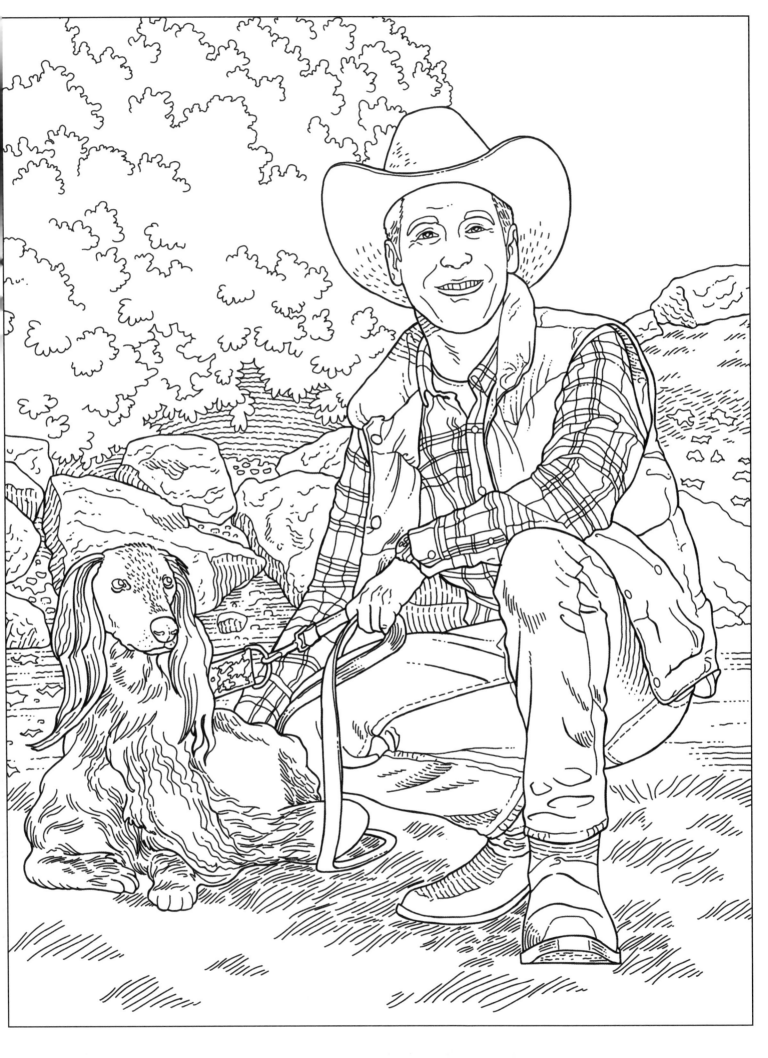

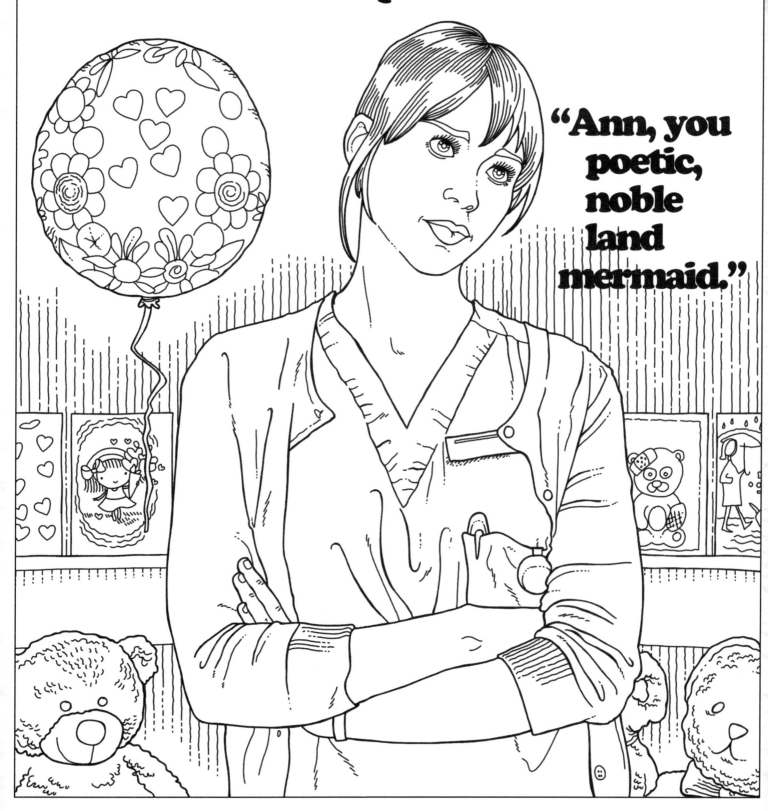

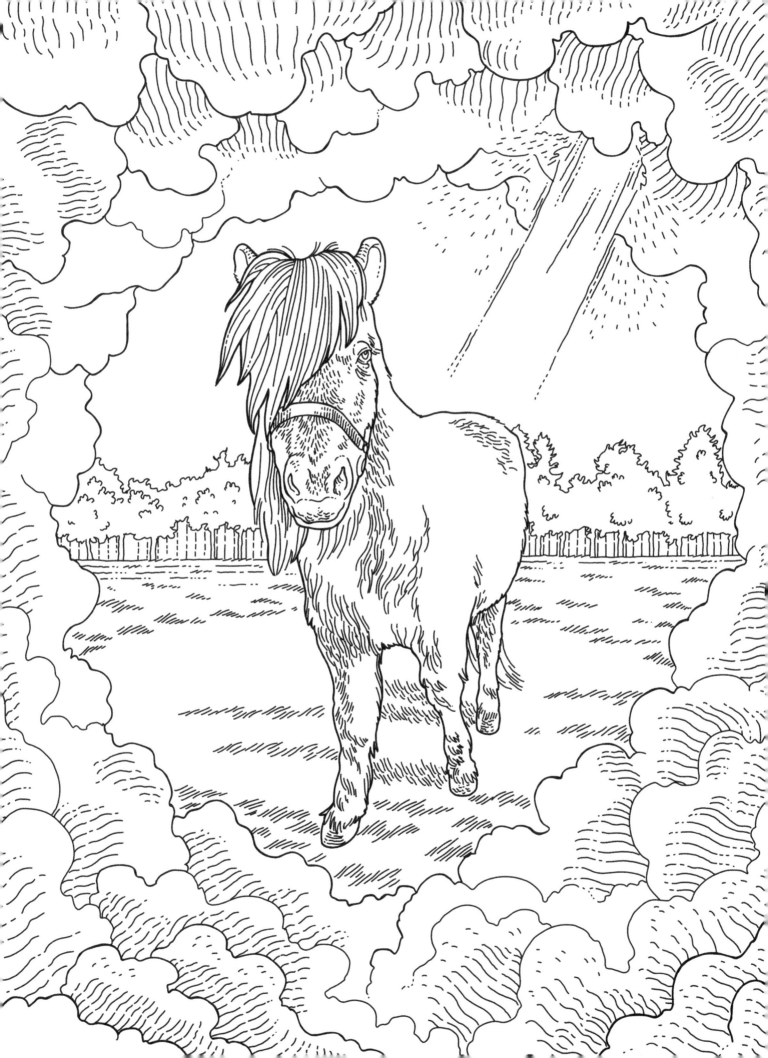

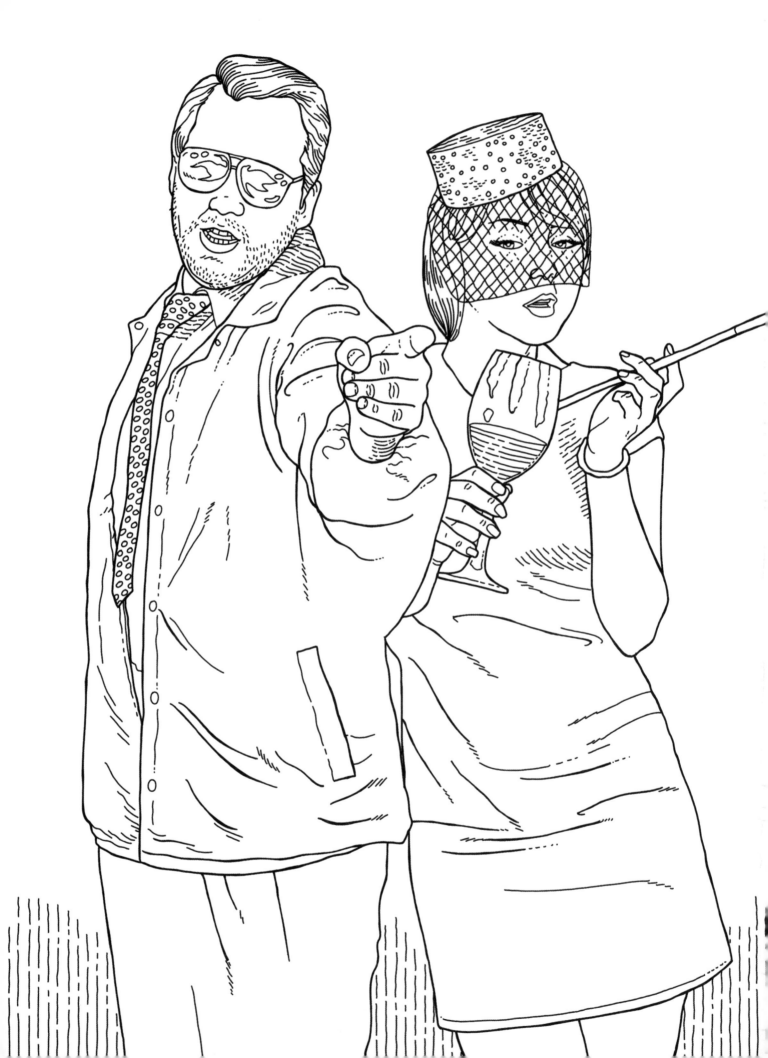

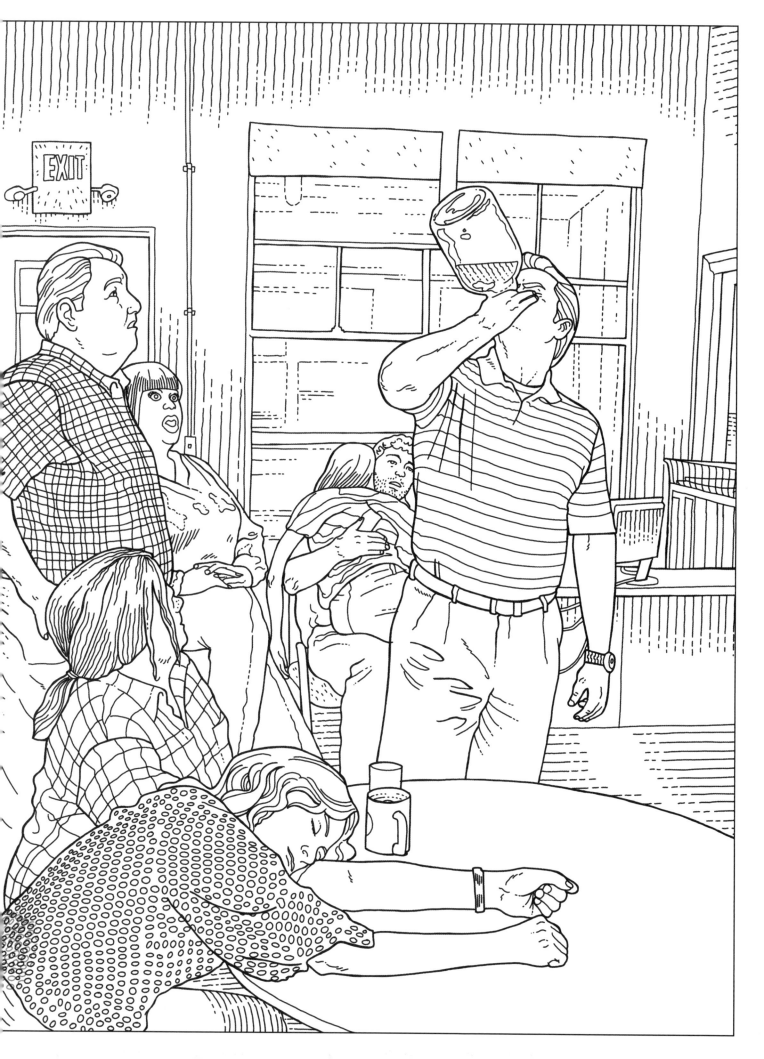

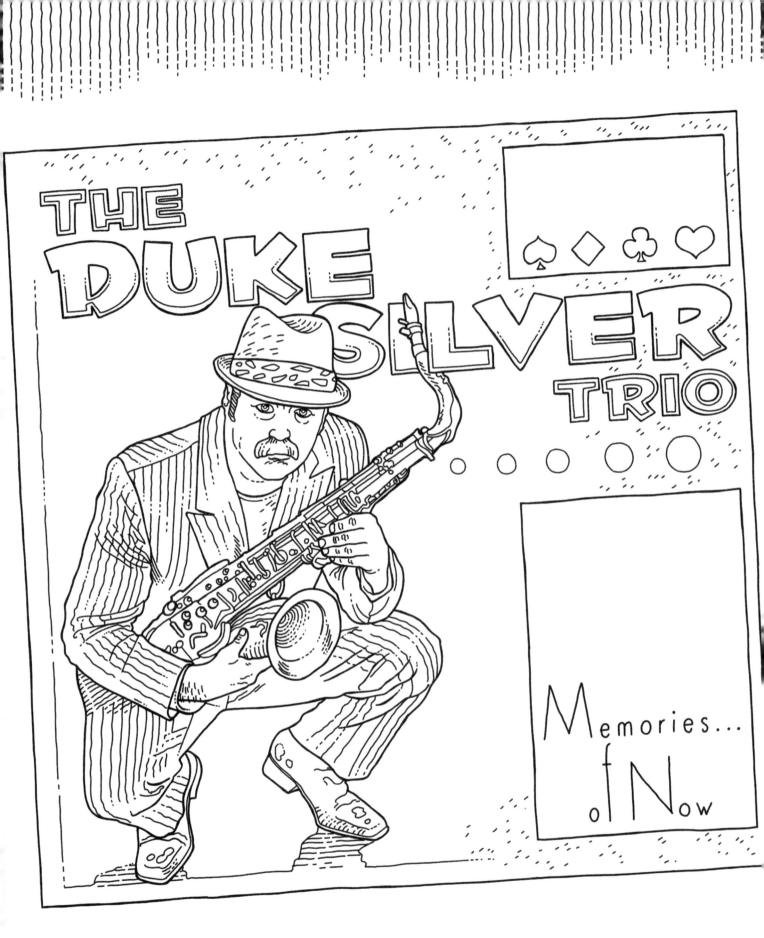

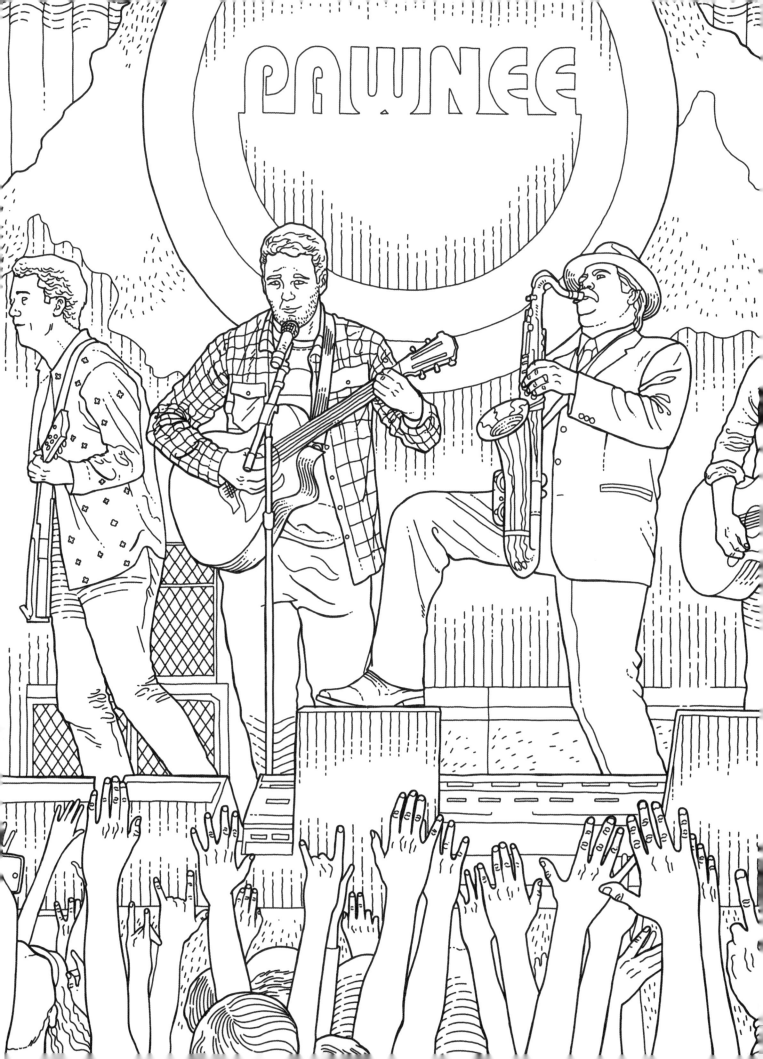

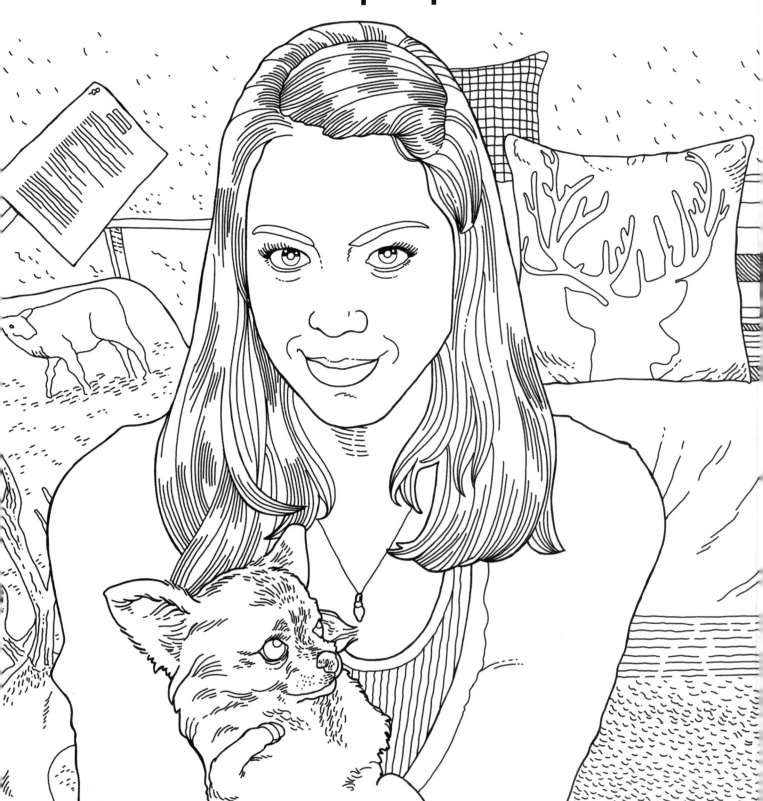

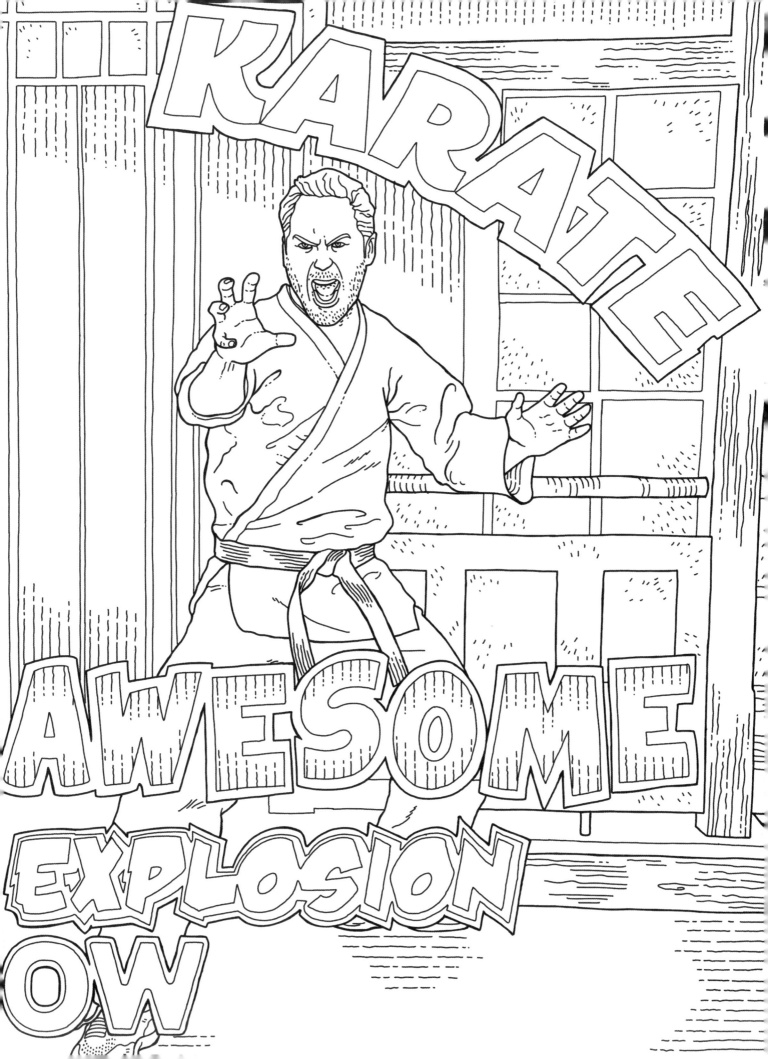

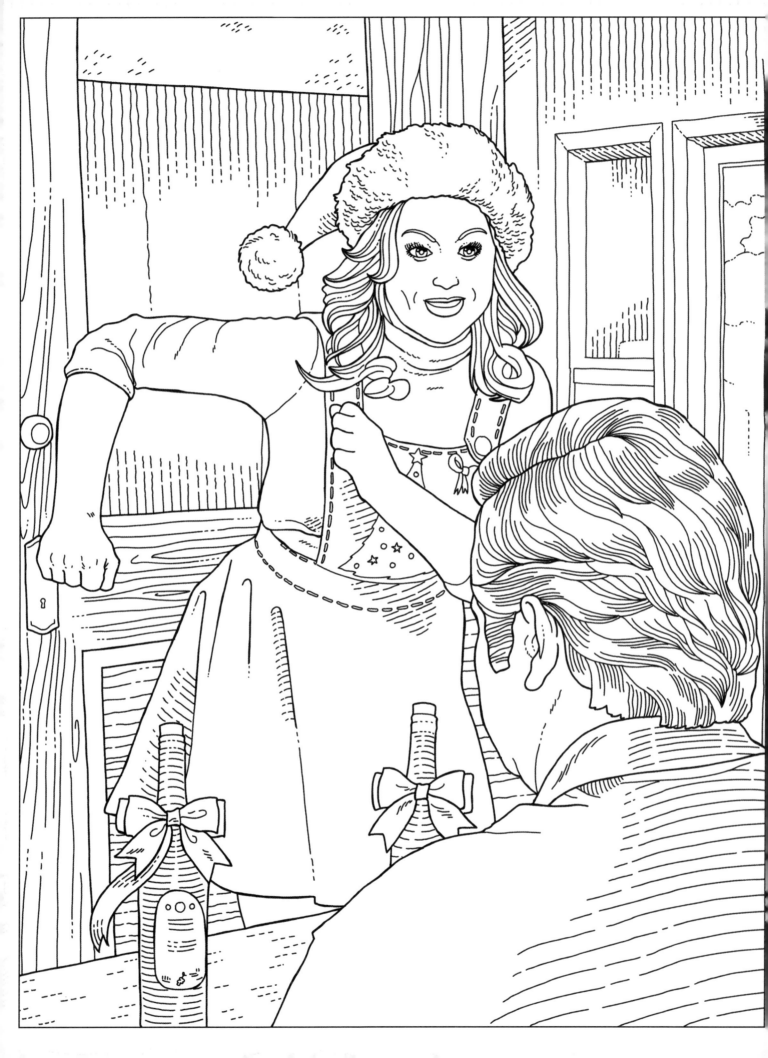

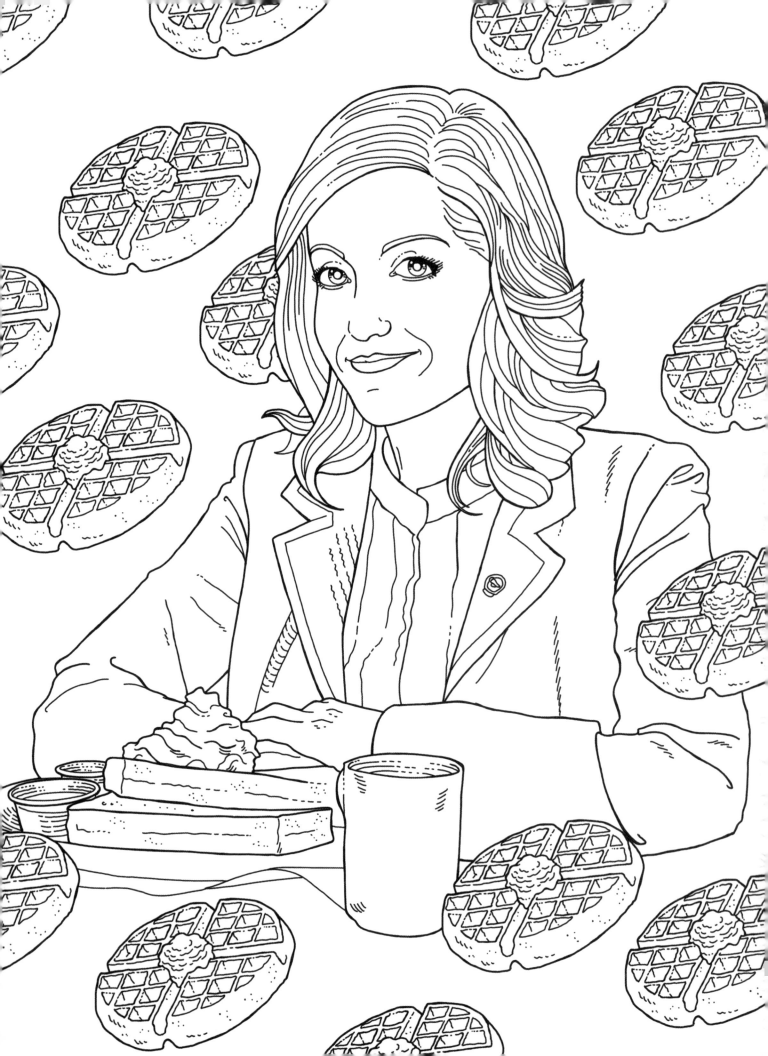

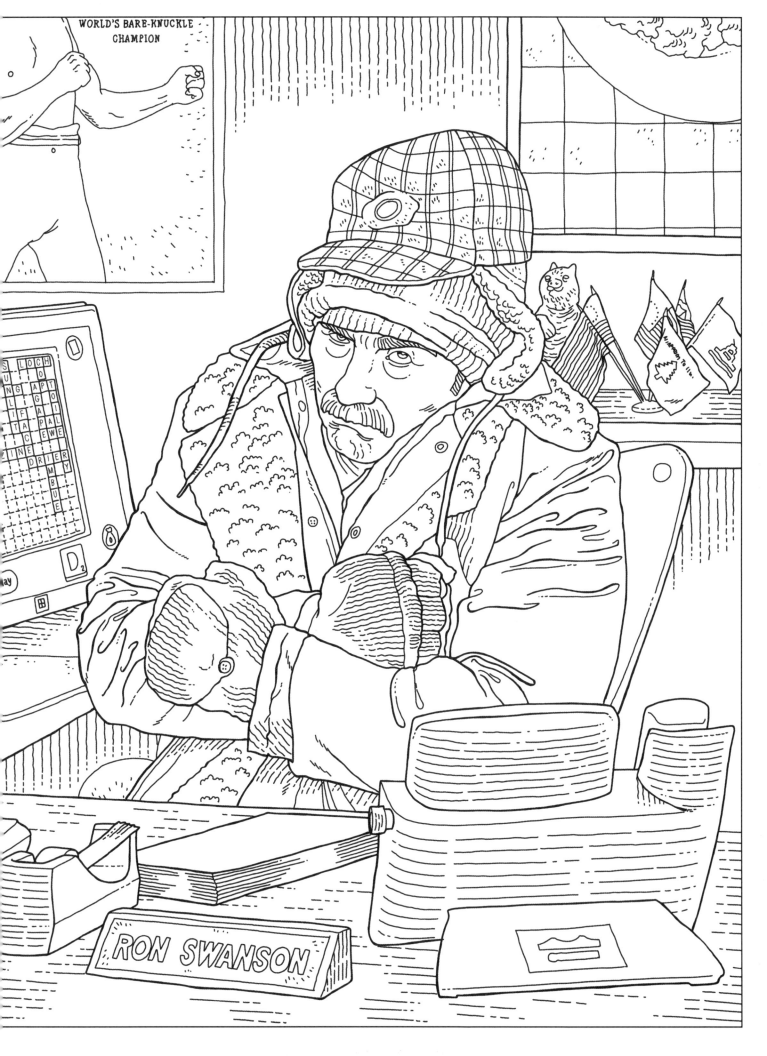

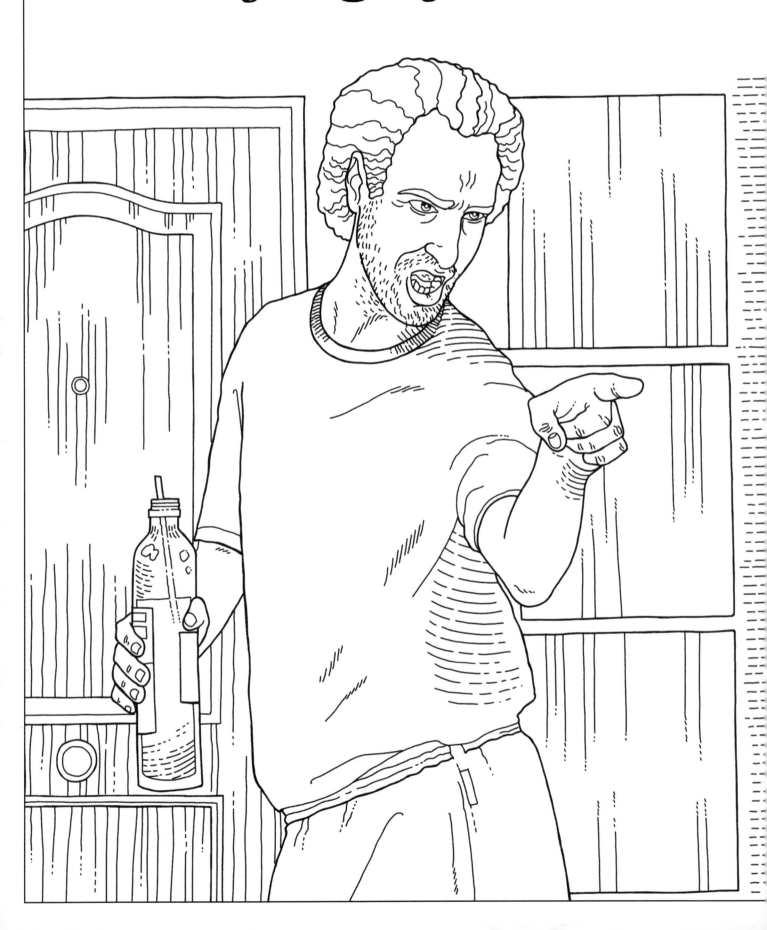

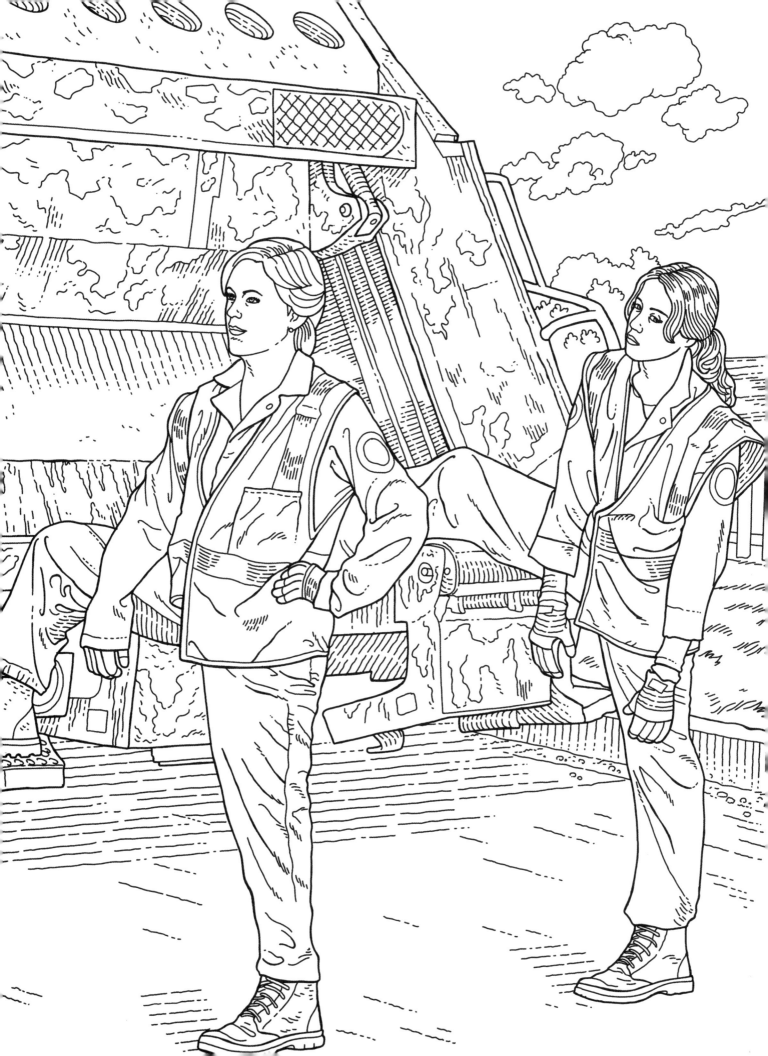

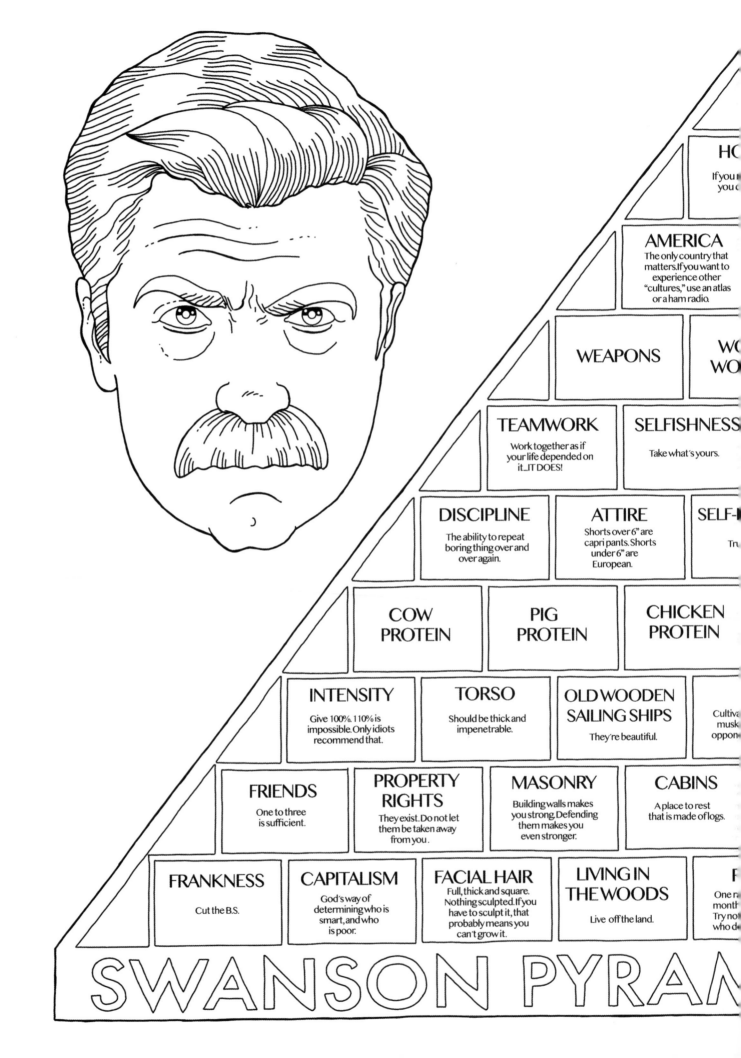

HO
If you
you d

AMERICA
The only country that
matters. If you want to
experience other
"cultures," use an atlas
or a ham radio.

WEAPONS

WO
WO

TEAMWORK
Work together as if
your life depended on
it...IT DOES!

SELFISHNESS
Take what's yours.

DISCIPLINE
The ability to repeat
boring thing over and
over again.

ATTIRE
Shorts over 6" are
capri pants. Shorts
under 6" are
European.

SELF-
Tru

COW
PROTEIN

PIG
PROTEIN

CHICKEN
PROTEIN

INTENSITY
Give 100%. 110% is
impossible. Only idiots
recommend that.

TORSO
Should be thick and
impenetrable.

OLD WOODEN
SAILING SHIPS
They're beautiful.

Cultiva
musk
oppon

FRIENDS
One to three
is sufficient.

PROPERTY
RIGHTS
They exist. Do not let
them be taken away
from you.

MASONRY
Building walls makes
you strong. Defending
them makes you
even stronger.

CABINS
A place to rest
that is made of logs.

FRANKNESS
Cut the B.S.

CAPITALISM
God's way of
determining who is
smart, and who
is poor.

FACIAL HAIR
Full, thick and square.
Nothing sculpted. If you
have to sculpt it, that
probably means you
can't grow it.

LIVING IN
THE WOODS
Live off the land.

F
One ra
month
Try not
who d

SWANSON PYRA

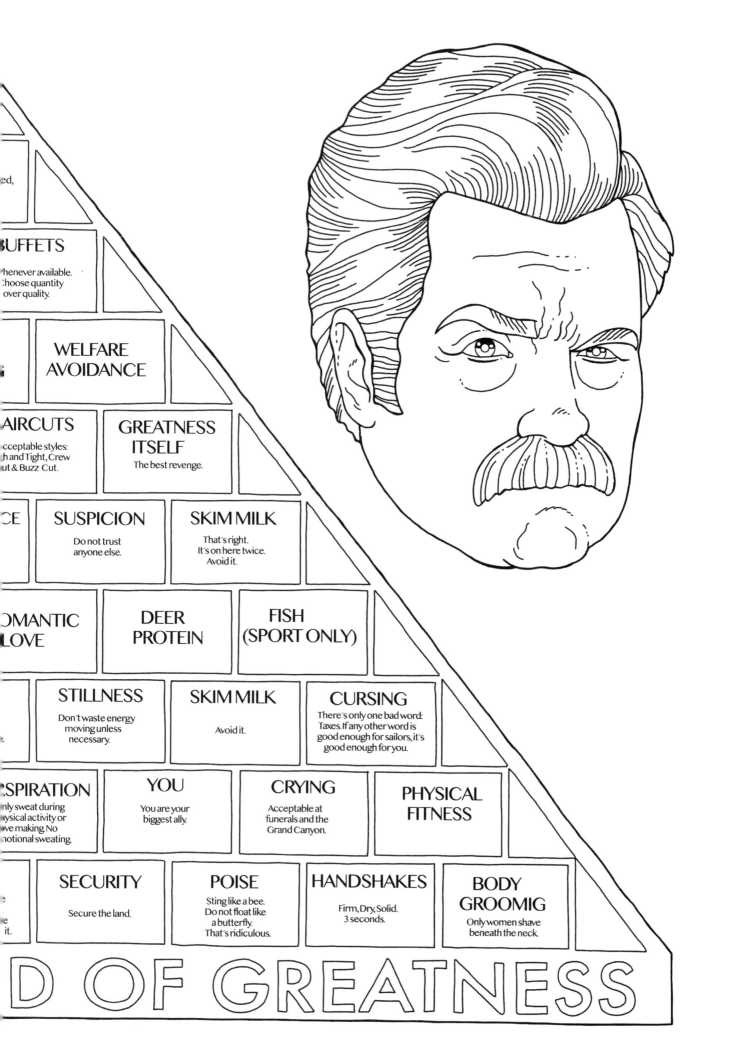

**BUFFETS**

...henever available.
...choose quantity
over quality.

**WELFARE
AVOIDANCE**

...AIRCUTS

...cceptable styles:
...h and Tight, Crew
...ut & Buzz Cut.

**GREATNESS
ITSELF**

The best revenge.

**SUSPICION**

Do not trust
anyone else.

**SKIM MILK**

That's right.
It's on here twice.
Avoid it.

...OMANTIC
...LOVE

**DEER
PROTEIN**

**FISH
(SPORT ONLY)**

**STILLNESS**

Don't waste energy
moving unless
necessary.

**SKIM MILK**

Avoid it.

**CURSING**

There's only one bad word:
Taxes. If any other word is
good enough for sailors, it's
good enough for you.

...SPIRATION

...nly sweat during
...hysical activity or
...ve making. No
...motional sweating.

**YOU**

You are your
biggest ally.

**CRYING**

Acceptable at
funerals and the
Grand Canyon.

**PHYSICAL
FITNESS**

**SECURITY**

Secure the land.

**POISE**

Sting like a bee.
Do not float like
a butterfly.
That's ridiculous.

**HANDSHAKES**

Firm, Dry, Solid.
3 seconds.

**BODY
GROOMIG**

Only women shave
beneath the neck.

D OF GREATNESS

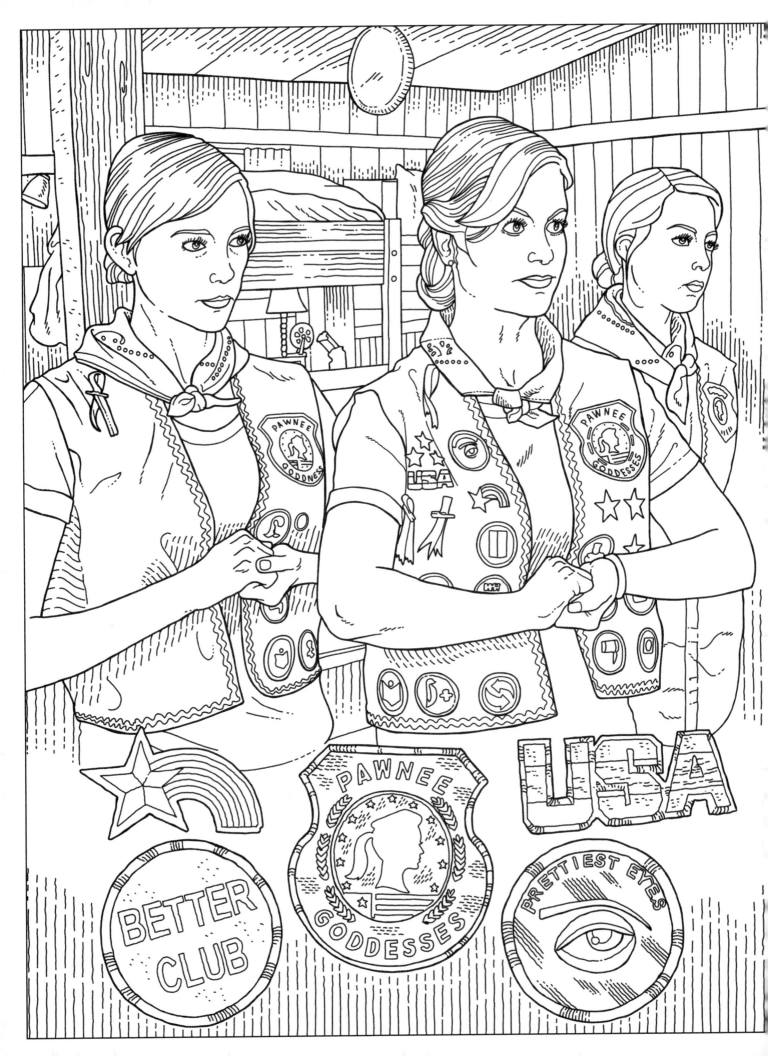

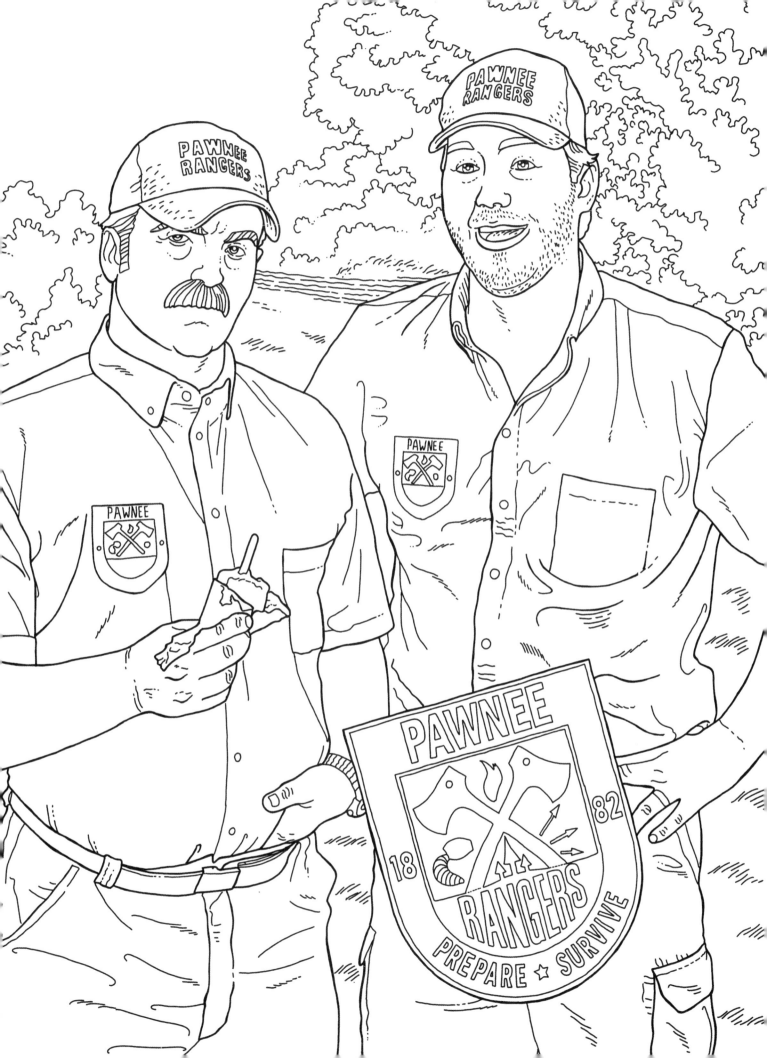

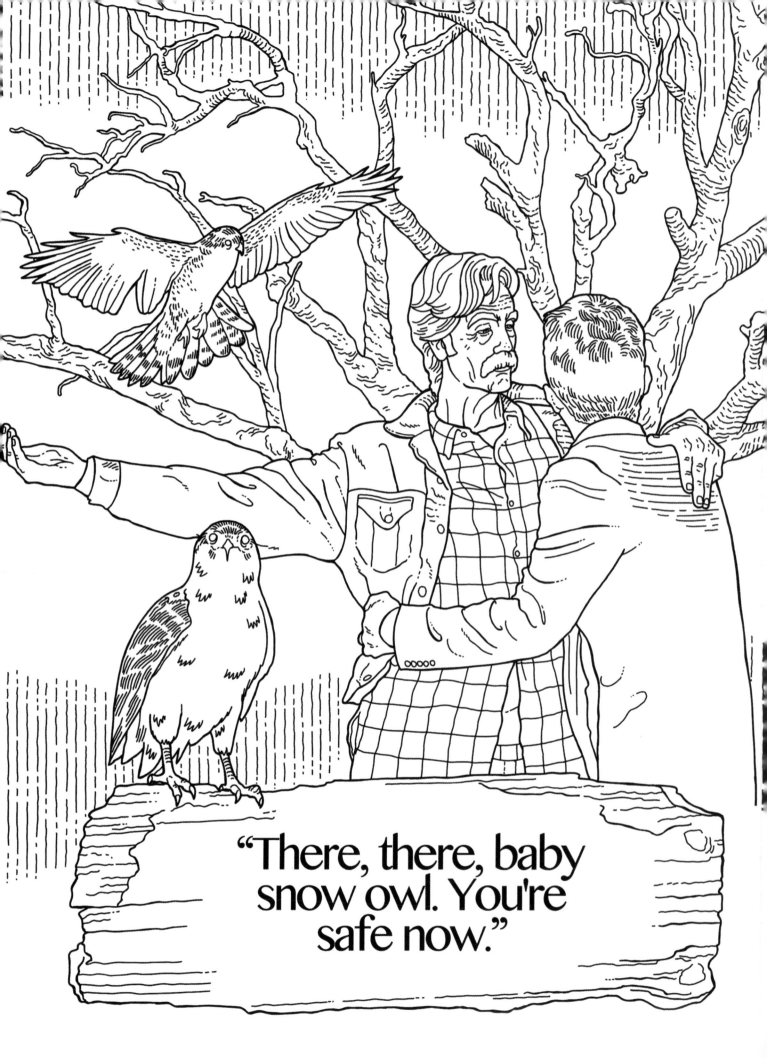

"There, there, baby snow owl. You're safe now."

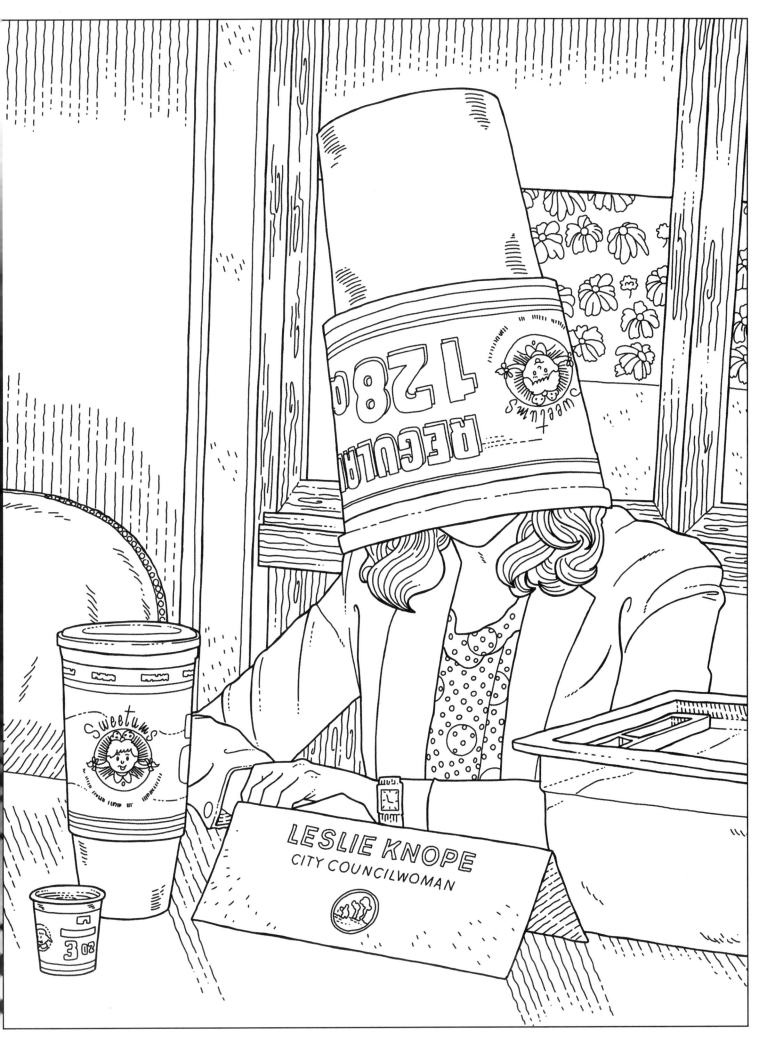

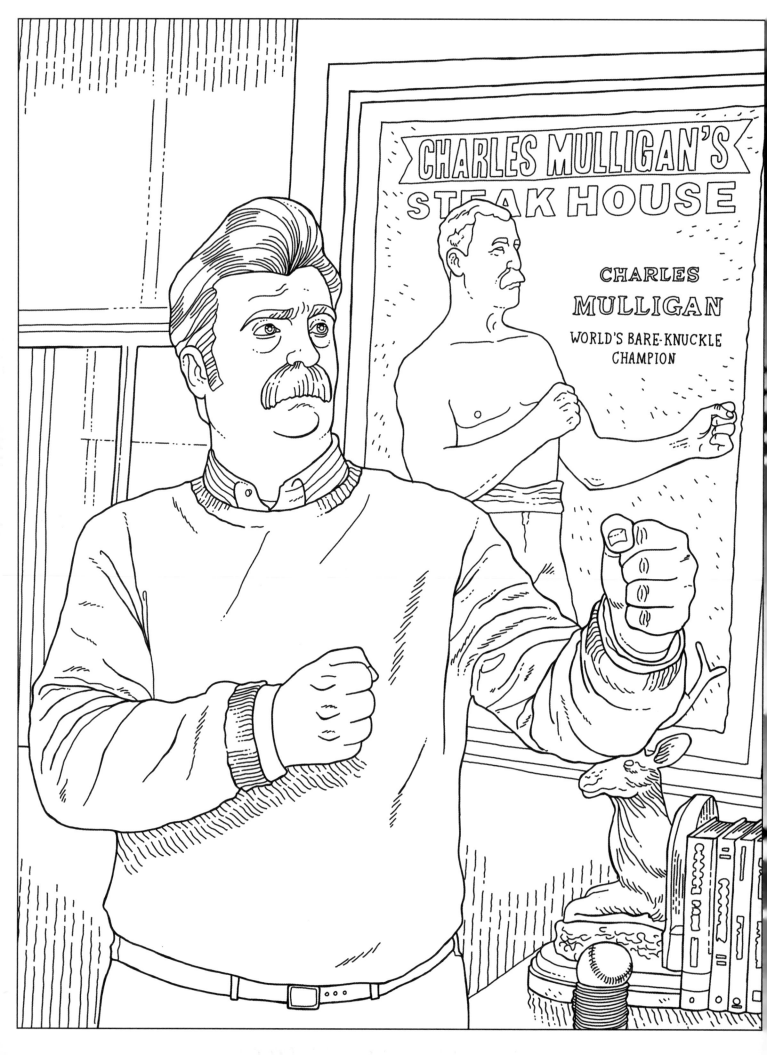

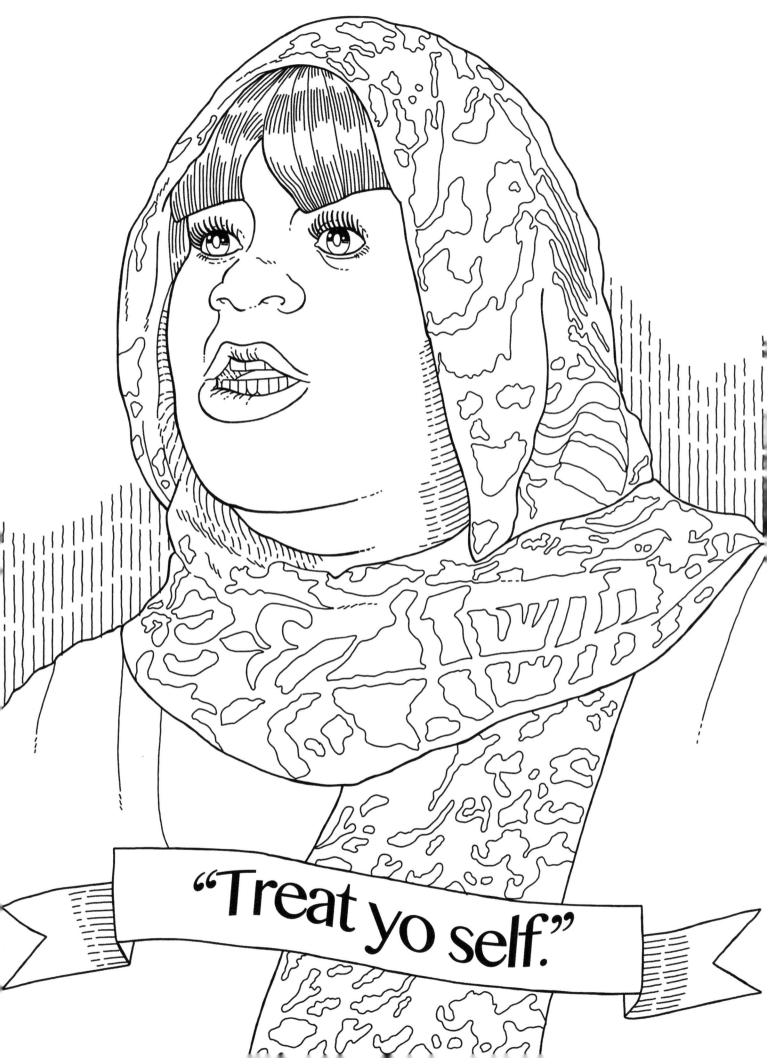

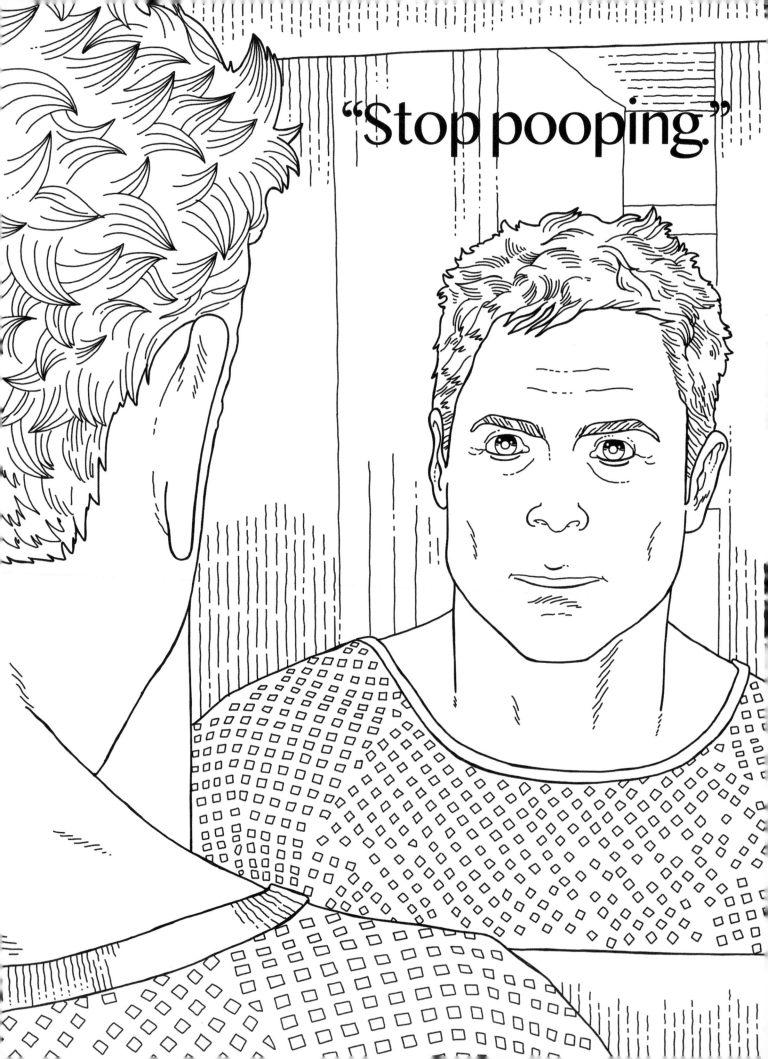

# PAWNEE PARKS DEPARTMENT
# WANTED
## MOST WANTED PESTS LIST

"POOPY"

"VLAD"

"FAIRWAY FRANK"

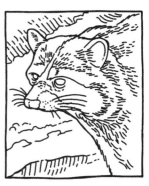
"ZORRO"

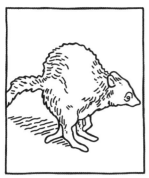
"ONE PAW PAPA"

"SPYKE"

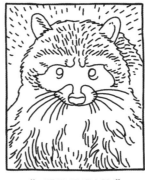
"WIREY RIDLEY"

"JANGLE BO JINGLES"

"LEANOR"

"NUTZ"

Please report any sighting of the above felons to Pawnee Animal Control at: 555-0148 x 213

DO NOT ATTEMPT TO CAPTURE THESE PESTS ON YOUR OWN.

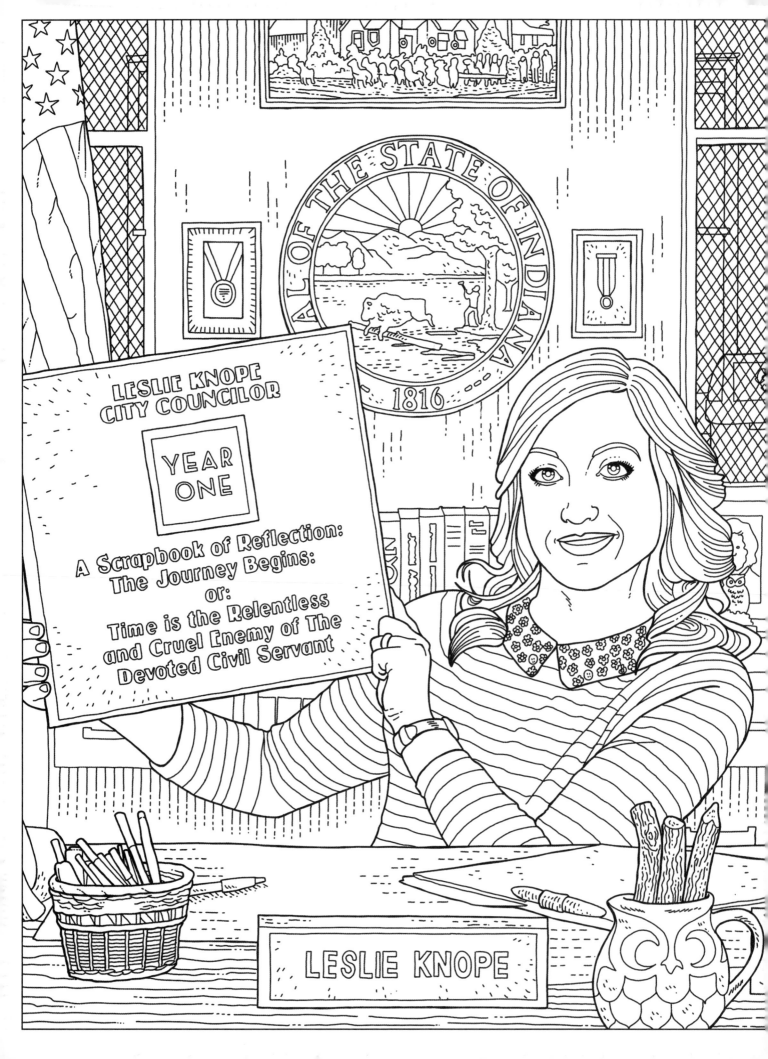

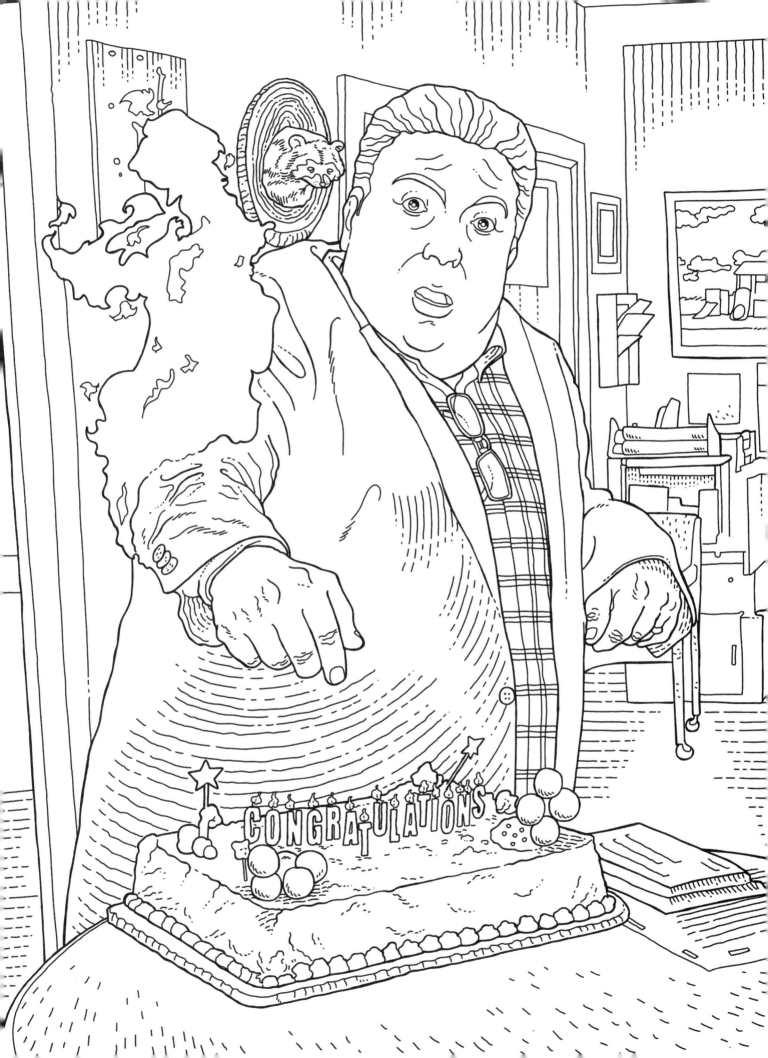

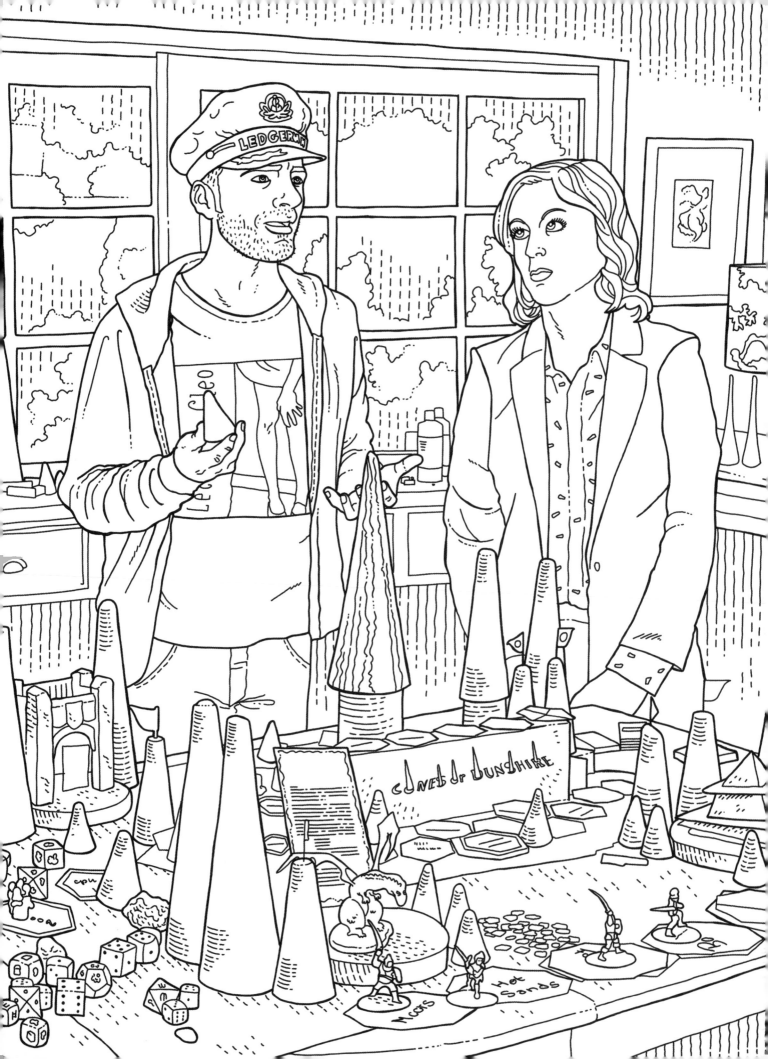

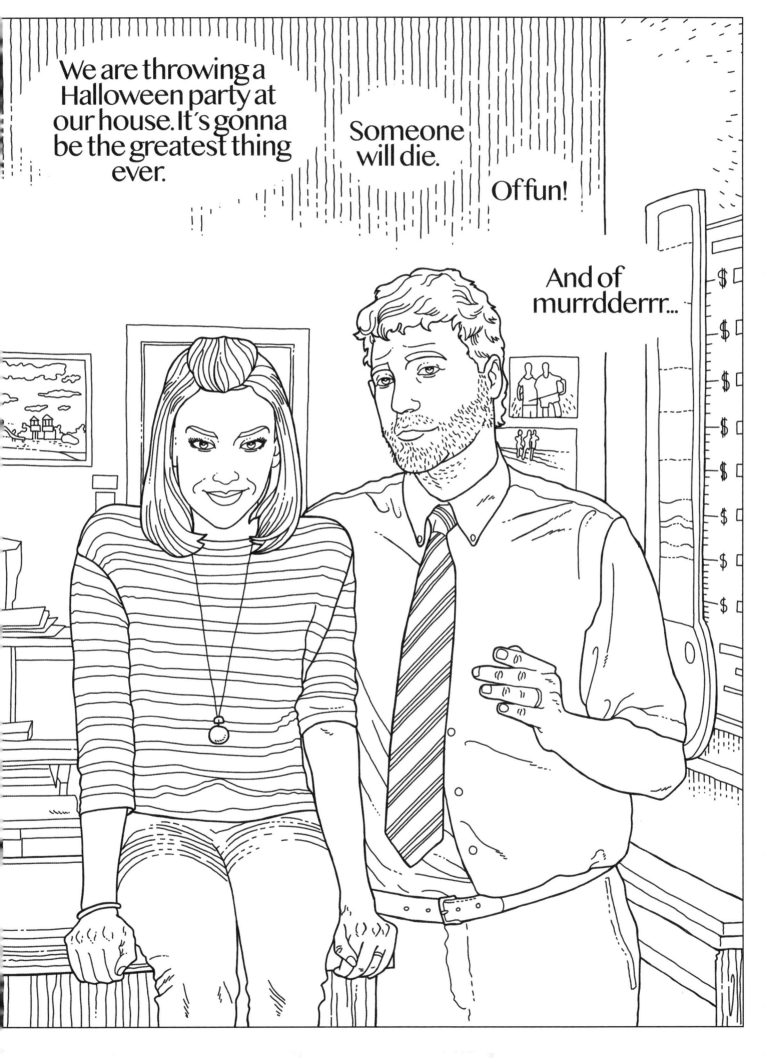

I N S I G H T
E D I T I O N S

PO Box 3088
San Rafael, CA 94912
www.insighteditions.com

 Find us on Facebook: www.facebook.com/InsightEditions
 Follow us on Twitter: @insighteditions

**peacock**

ISBN: 978-1-64722-682-4

INSIGHT EDITIONS
Publisher: Raoul Goff
VP of Licensing and Partnerships: Vanessa Lopez
VP of Creative: Chrissy Kwasnik
VP of Manufacturing: Alix Nicholaeff
VP, Editorial Director: Vicki Jaeger
Designer: Amy DeGrote
Editor: Harrison Tunggal
Managing Editor: Maria Spano
Senior Production Editor: Katie Rokakis
Production Associate: Tiffani Patterson
Senior Production Manager, Subsidiary Rights: Lina s Palma-Temena

ROOTS of PEACE   REPLANTED PAPER

Insight Editions, in association with Roots of Peace, will plant two trees for each tree used in the manufacturing of this book. Roots of Peace is an internationally renowned humanitarian organization dedicated to eradicating land mines worldwide and converting war-torn lands into productive farms and wildlife habitats. Roots of Peace will plant two million fruit and nut trees in Afghanistan and provide farmers there with the skills and support necessary for sustainable land use.

Manufactured in Turkey by Insight Editions

10 9 8 7 6 5 4 3 2 1